MURDER & MAYHEM
IN THE
CATSKILLS

CAROLINE CRANE

Charleston H London

THE
History
PRESS

Published by The History Press
Charleston, SC 29403
www.historypress.net

Copyright © 2008 by Caroline Crane
All rights reserved

Cover design by Marshall Hudson

First published 2008

Manufactured in the United States

ISBN 978.1.59629.548.3

Library of Congress Cataloging-in-Publication Data

Crane, Caroline.
Murder and mayhem in the Catskills / Caroline Crane.
p. cm.
Includes bibliographical references.
ISBN 978-1-59629-548-3
1. Crime--New York (State)--Catskill Mountains--History--Anecdotes. 2. Murder-
-New York (State)--Catskill Mountains--History--Anecdotes. 3. Violence--New
York (State)--Catskill Mountains--History--Anecdotes. 4. Criminals--New York
(State)--Catskill Mountains--Biography--Anecdotes. 5. Curiosities and wonders-
-New York (State)--Catskill Mountains--Anecdotes. 6. Catskill Mountains (N.Y.)-
-History--Anecdotes. 7. Catskill Mountains (N.Y.)--Biography--Anecdotes. I.
Title.
HV6795.C397C73 2008
364.152'30974738--dc22
 2008029066

CONTENTS

CONTENTS

ACKNOWLEDGEMENTS

This book was not as easy to write as I expected. The Catskill Mountains are basically a pleasant place. There is not much murder and mayhem going on. Eventually, however, I found enough cases to write about that I hope will prove as interesting to readers as they did to me. I was greatly helped in this endeavor by the gangsters of the 1930s and '40s who, aside from enjoying vacations in the mountain area, also used it for their illegal operations, their murders and for disposing of the results of those murders.

More recently, other—and more law-abiding—individuals gave me enormous assistance. I would like to thank John Conway, the Sullivan County historian, who provided some of the background material as well as a number of illustrations. Frances Crane did a noble job of preparing the photographs for print. Joseph Morgan supplied both a story and the accompanying pictures. James Ryo Kiyan created the map of the Catskills area seen at the front of this book and photographed the Stone Arch Bridge, where one of the more preposterous murders took place.

I would also like to thank Frank Rizzo of the *Sullivan County Democrat* and Steve Hopkins of the *Saugerties Times* for their permission to use material from their papers. My gratitude to all of you for your very valuable assistance.

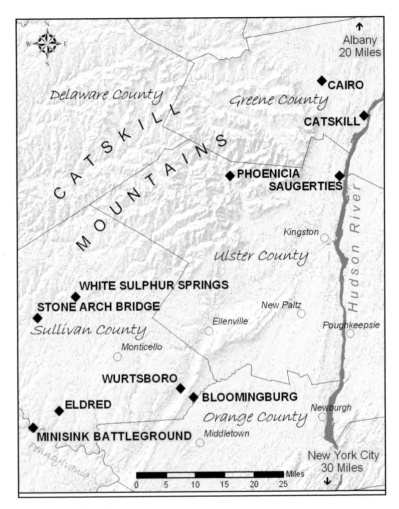

Map by James Ryo Kiyan.

INTRODUCTION

The Catskill Mountains are home to the residents of several New York State counties. To many others, they are a popular recreation area offering diversions for every season of the year.

Catskill history has its dark side as well. The beasts of the forests are not the only ones that prey on each other. All too often human beings do as well. The causes of murder are many. In fact, it can be tritely said that there are as many causes as there are murderers. Each person has his individual take on things and his individual reaction to events both great and small. Basically, however, that list can be boiled down to a few motivations, such as greed, revenge, a need for power, a need to escape from power... Even a basic list can grow. Killing might result from war, as in the first chapter of this book, on the border wars and the American Revolution. In all these cases, life, which ought to be held sacred, is cheap. It's the mind of the murderer, the idea of someone willing to deprive another person of life, that never ceases to fascinate. Which is why we keep reading about murders.

In the early decades of the twentieth century, murder became a business. Aside from Brooklyn, another place seriously affected by this was the Catskill region. Gangsters were already acquainted with these mountains. They liked to vacation here. Because they were often in the area, it's where many of their

murders took place. Not only was there plenty of unused land for burying bodies, there were all the lakes as well. That was easier than trying to dig through tree roots. Weigh down a body so it doesn't rise to the surface, dump it in a lake and who would ever know? On that they occasionally miscalculated, to the horror of innocent vacationers. Walter Sage's and Maurice Carrillot's bodies were two that surfaced. From those events, the professional killers of Murder, Incorporated undoubtedly learned their lesson.

In the days of Prohibition, from 1920 to 1933, the gangsters raked it in with bootlegging and illegal brewing. When Prohibition ended, they had to find other ways to make a profit. Racketeering was always good. There were many ways of doing that, and many places in which to do it. Slot machines were rife in the Catskills. So were rivalries and murders. After a while the big crime bosses decided that rivalry and murder were not the way to go, and that they would all do better if they united the various factions into one whole. They called it the "Commission" or the "Combination." Another term for it was Syndicate.

For its own protection, the Syndicate had a strict code of laws that had to be obeyed and could not be revealed. Anyone guilty of infraction either way was asking for trouble. With those rules laid down, the murder rate dropped, although it did not disappear entirely. The heyday of gangsterism in the Catskills faded away. The heyday of the giant Borscht Belt resorts came and also eventually faded.

Still, being the imperfect creatures that we are, humans continue to murder and probably always will. It doesn't take a gangster, or gang rivalry, to cause death. That is evident in the final chapter, "Murder and Mayhem in the Modern Era."

First in that section is the Reverend LeGrand, who presided over a church in Brooklyn and a summer camp in the Catskills. He also had some questionable working methods and some questionable personal habits. When he felt his secrets were about to be spilled, he had a way of dealing with that.

There was the son who killed his parents when they tried to get him off drugs. There were men who killed their girlfriends, husbands who killed wives and wives who killed husbands. Even earlier, there was the legendary (but all too real) hex murder that came about for no other reason than ignorance and superstition. And there was the recent release of Dr. Charles Friedgood, who performed his evil deed on Long Island but, as a result, spent almost half his life as one of the Catskills' own—in prison. All these people had their reasons for doing what they did. Some may have regretted it afterward, others not. Usually the killers made some attempt to conceal their crimes. That's not always an easy thing to do. People killing in the heat of passion often fail to plan ahead. They find themselves, appallingly enough, with a body on their hands. At other times, the killer might come within an inch of getting away with it. Then it turns out he made one seemingly insignificant mistake. That was the case with Hal Karen, who provides the final murder story in our book.

EARLY BLOODSHED

Human beings have been shedding one another's blood since long before history began. The cause may be just, or it may not. When it isn't, people are capable of convincing themselves that it is. In wartime, this can happen on a mass scale.

Even before the Revolutionary War began, white settlers felt entitled to take what land they needed or wanted. The Indians didn't actually "own" it, they told themselves (more about that later). The Indians felt they were being overrun and taken advantage of, and their only recourse was to drive the settlers away.

Claudius Smith also had the idea that it was his right to take rich people's wealth if he wanted it, and if he could get it, especially if those people were on the side of the enemy. As for Gross Hardenburgh, he started out as a difficult youth, and later kept his tyrannical nature well fueled with drink.

The fourth story in this section tells of a death that was an accident, though avoidable if the perpetrator had thought through his actions. It happened as a result of a sociological condition that no longer exists, at least legally, in the United States. It's true, however, that all too often people still don't think. And accidents continue to happen.

Joseph Brant, the Border Wars and the Revolution

One of the most infamous killers in Catskills history, Joseph Brant, may have gotten a worse rap than is warranted by the facts. It's true that he did a lot of damage and was much feared in his day. His picture, along with those of several gangsters, hangs on the "Wall of Shame" at the Sullivan County Historical Society Museum. But there were mitigating factors, some historical and some attributable to Brant's own character.

The Catskills and surrounding lands provided boundless riches for its early inhabitants. Its forests were filled with game and with plentiful lakes and trout streams. The soil, though rocky, was rich and arable for growing corn, beans and other crops.

The earliest settlers were Leni-Lenape, who built their houses and villages around the numerous lakes. Those lakes gave them fish and drinking water, as well as a means of transportation. The first European known to have settled in what is now Sullivan County was Manuel Gonsalus, a Spaniard married to a Dutch woman. His Spanish name, Gonzales, became "Dutchified" in its spelling. He bought farmland from the Indians and built a house in the Mamakating Valley sometime around 1760. There he farmed and traded peaceably with his neighbors. He is said to have constructed the first sawmill in the country. Other Europeans followed. They, too, bought land and built houses.

Soon, however, relations with the Indians began to deteriorate. The land deals were not always honorable. The Indians, more sophisticated than the colonists first thought, noticed that on a number of occasions they were being cheated. We all know, for instance, about Peter Minuit buying the island of Manhattan for a paltry twenty-four dollars. Even at that time, it was an absurdly low price. In the Catskills, Major Johannes Hardenburgh bought most of what is now Sullivan County for

the sum of sixty pounds. This was still a very small amount for so large a territory, which became known as the Hardenburgh Patent. Gonsalus himself, it seems, fell under the spell of greed. In retaliation, the Indians kidnapped two of his children, who eventually escaped.

Aside from out-and-out cheating, there was a vast difference in viewpoint as to what land ownership meant. The Indians regarded the earth as a resource, like air and water, which was open to everyone. Personal and permanent ownership was not part of their thinking. At first, they assumed they were merely granting rights to use the land. If the white men wanted to pay for those rights, it was fine with them.

When the white men saw how easy it was to gain land in this way, many of them did take advantage. With that, both the honest and the dishonest found themselves no longer welcome in the mountains and valleys where they had settled. Many of the Indians with whom they had traded now decided it was time for the land grabbers to disappear.

The colonists built forts to protect themselves. Because of that mutual hostility, when the Revolutionary War began, many Indians sided with the British. One of their leaders was a Mohawk chief named Thayendanegea, better known as Joseph Brant. Brant was no stranger to white men. According to church records, his parents were Christian. As a youth, he came to the attention of Sir William Johnson, the British superintendent for Northern Indian affairs, a man highly respected by the tribes under his auspices. Johnson was a Freemason and Brant followed his example. With Johnson's influence, Brant was able to attend a school for Indian youth at what is now Dartmouth College. The bond between the two men was further strengthened when Johnson married Brant's sister Molly. Brant had learned English early, and frequently acted as an interpreter between the British and the Mohawks. He also translated parts of the Bible into the Mohawk language and tried to Christianize his people.

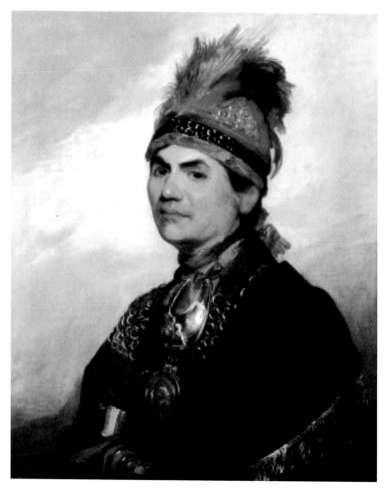

Joseph Brant. *Painting by Gilbert Stuart.*

With the beginning of the Revolutionary War, the six nations of the Iroquois League—the Cayuga, the Mohawk, the Oneida, the Onandaga and the Seneca, as well as the Tuscarora from North Carolina—held a meeting. They found themselves divided as to whether they should side with the British Tories or with the American Patriots. Several favored neutrality, on the grounds that

the fight had nothing to do with them. Brant argued for the British. In his opinion, if the Patriots won, they would continue taking land away from the Indians. For his loyalty, as well as his intelligence and his ties with Johnson, he was awarded a captain's commission in the British army. With that rank, he led troops consisting of both Indians and British Loyalists. Often the Loyalists would disguise themselves as Indians and were as avid as anyone when it came to taking scalps. Governor George Clinton referred to those Tories as "cruel monsters, worse than savages."

Brant's aim was to demoralize the Patriots and force them to back down. His troops rampaged through upstate New York, destroying farms and villages. A 1778 attack on the fort at Cherry Valley, which lies between present-day Utica and Schenectady, caught the inhabitants unprepared. Men, women and children were killed by Indians and Tories alike in what has become known as the Cherry Valley Massacre.

Brant took most of the blame for that because the troops were under his command. In numerous instances, however, he is described by historians as having been, or attempted to be, a voice of reason. In one famous instance, a captured Patriot was about to be tortured and put to death. Knowing that Brant was a Freemason, he made the secret Masonic sign of brotherhood. Brant intervened and caused his life to be spared. Sometime later, when Brant learned that the man was not really a Mason, he was furious at the deception, but still let his prisoner live.

On another occasion, a group of Patriot prisoners was being marched for incarceration within the fort at Schoharie. During an overnight stop along the way, the men were guarded by a Tory named Becraft, a cruel lout of a man. He whiled away the night hours by taunting his charges about the tortures that awaited them at their destination. When day came, Becraft and his companions were eager to massacre the prisoners, no doubt not very pleasantly. Brant refused to allow it.

Brant showed mercy at other times as well. Sources quote him, though perhaps not at Cherry Valley, as having ordered his followers to abstain from killing women and children. Nevertheless, this was war, and the raids continued on through New York State, New Jersey and Pennsylvania.

The Americans retaliated, murdering Indians in turn and taking scalps. A bounty, in fact, was placed on Indian scalps. Major General John Sullivan of the Continental army swept through Indian villages, burning homes, destroying crops and killing the inhabitants. Sullivan is quoted as declaring, "The Indian shall see that there is malice enough in our hearts to destroy everything that contributes to their support." He was as good as his word.

On the night of July 19–20, 1779, Brant and a party crept up on Minisink, a long-established settlement in southern Sullivan County, near the shores of the Delaware River. So silent was their approach that they had set several homes on fire before the inhabitants knew they were there. Before leaving, they succeeded in burning a number of houses and barns, some mills and a small fort. They also made off with prisoners and all the loot they could gather.

Refugees from the ravaged settlement hurried to rouse the local militia at Goshen, some ten miles away. Colonel Tusten, the militia commander, rallied his men and a group of volunteers to pursue the Indians and free the prisoners, as well as take back the horses, cattle and other property that had been stolen. Looking about at how few his numbers were, he thought they should wait for reinforcements before engaging Brant and his larger force. Others of his troops, perhaps with more bravado than brains, were eager to set off immediately. Soon they were joined by two more militia units and they began their march. After a while they came upon a site where the enemy had camped overnight. From the size of the place, Tusten saw at once that they were greatly outnumbered. Again he wanted to wait, and again was outvoted.

By that time in the Revolution, the Americans had learned to fight Indian style, sniping from behind trees and rocks instead of

advancing in a very visible line, as the British had always done. They heard from their scouts that Brant intended to cross the Delaware at the Minisink Ford. Some of his troops had already done so, emerging on the Pennsylvania side. The militiamen, now enlarged by more forces commanded by Colonel Hathorn, lay in wait. When more of Brant's army arrived, they planned to ambush it.

Unfortunately, one of the men accidentally fired his weapon. That alerted Brant and gave away the militia's position. He circled

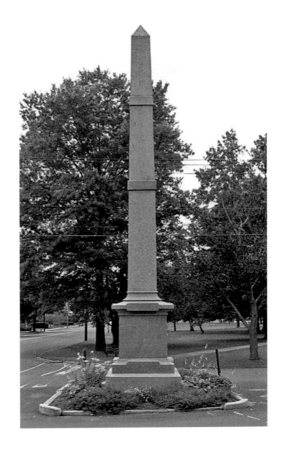

The Minisink
Monument at Goshen.

around and managed to cut the units off from each other. The militiamen retreated as best they could while nearly surrounded. Their retreat led them up a hill to a spot now commemorated as Sentinel Rock. For most of the day they held fast, though running dangerously low on ammunition. When one of their guards was killed, Brant's forces poured through the breach and surrounded the Goshen militia. Colonel Hathorn's troops, for the most part, managed to get away. Colonel Tusten, who was a physician, did his best to help the wounded, until he was cut down by a tomahawk.

Brant claimed later that he had urged the militiamen to surrender and promised them amnesty. As he stood in plain sight, making the offer, someone fired and nearly hit him. The offer was withdrawn.

That ended the battle of Minisink. It was the only major battle fought in Sullivan County and the site is now commemorated as the Minisink Battleground Park.

Despite Brant's efforts, the tide eventually turned. When the Tories lost the war, Brant and his followers found refuge in Canada, where he lived in comparative comfort for the rest of his life. That community is now known as Brantford, Ontario.

It took many years to round up the American remains from the battle of Minisink. Finally, in 1822, the bones that were collected found a home in Goshen, New York, where a monument was erected to honor the fallen.

Claudius Smith, Tory Outlaw

Just east of the southern Catskills, across a narrow valley, are the Shawangunk Mountains. Pronounced "Shawn-gum," the name is an Indian word for "white rock." Spectacular white granite cliffs rise straight up in the New Paltz area and are a big draw for the rock-climbing crowd. Farther south in the "Gunks," as the rock climbers call them, was the site of much mayhem caused by Claudius Smith and his notorious outlaw band.

Claudius was a large and powerful man who began his thieving at an early age. His father is said to have encouraged him in that enterprise. Not so his mother: in despair, she warned her son, "Claudius, one day you will surely die with your shoes on." She must certainly have hoped that he would mend his ways and die peacefully in bed.

Undeterred, Claudius collected about him a gang of like-minded outlaws whose number eventually included two of his sons, William and James. Their hideout was a nearly inaccessible cave high on a mountainside in what is now Harriman State Park. From there they would sweep down into the surrounding countryside to plunder and kill, and then carry their loot back to the safety of the den. As Loyalists, they found a ready market among the British forces stationed nearby. Not only did the Tories buy their stolen goods, they offered protection as well. Claudius and his men did their best to annoy the colonial upstarts.

Despite his ruthlessness, Claudius managed to earn the reputation of being something of a benefactor. Of course he was selective in his benefactions, most of which went for his own welfare. Now and then he did show a glimmer of altruism. When Fort Montgomery fell to the British in 1777, its defender, Colonel McClaughry, was captured. Despite being a Whig, the colonel was someone Claudius knew. As a captive, McClaughry was confined to one of the British prison ships anchored in New York Harbor. Conditions on those ships were known to be miserable. Aware of that fact, the colonel's wife appealed to a wealthy neighbor, Abimal Young, for some money so her husband could buy food.

Young refused. When Claudius got word of it, he was indignant. "Why, that old miser. If he won't help Mrs. McClaughry, I'll take the money from him myself." He and his men invaded Young's house one night and took him prisoner. Even with his life threatened, Young would not part with any funds. Claudius had his men search the house. They found nothing of value.

Claudius knew there must be a fortune somewhere. He tied up Abimal Young and threatened to hang him from the well pole in his yard if he did not produce the cash. Young, living up to his tightfisted reputation, still refused. Claudius made good on his threat. He kept Young dangling until he was all but dead. Three times they strung him up and let him dangle. Young continued to resist. Another search of the house turned up a bundle of valuable papers consisting of bonds and property deeds. Claudius kept those, converted them into as much cash as he could and even shared some of it with Mrs. McClaughry.

For political reasons, Smith's favorite targets were the wealthy Whigs of the area. One such person was Major Samuel Strong, who woke one night to find his home overrun by outlaws. In those troubled times, most homeowners kept a firearm handy. The major seized his pistol and confronted the intruders. Claudius called out to him to set down his arms. In return, they would spare his life. Noting that he was outnumbered, the major accepted their offer. As soon as he complied, his attackers shot him dead.

When the news of Major Strong's murder reached Governor George Clinton, he put out a wanted notice, offering a large reward for Claudius and his two sons. Claudius took that very seriously. He abandoned his den and his gang and fled to the safety of Long Island.

Even that new location did not prove as secure as he hoped. One night a party of men broke into the house where he was sleeping and took him prisoner. They ferried him across Long Island Sound and turned him over to the sheriff of Orange County. The county seat then, as now, was Goshen, and there Smith was imprisoned.

It was not the first time he had seen the inside of a jail. On an earlier occasion, in Kingston, he had managed to escape. This time his jailers were determined it wouldn't happen and he was more heavily guarded. The trial took place on January 13, 1779. He was found guilty and sentenced to death by hanging.

In those days, execution was a public event. Notorious criminals such as Claudius attracted large crowds. Claudius never lost hope that his followers would manage a daring rescue. Even as he walked to the gallows, he was seen looking around expectantly. Unfortunately for him, his guard was too heavy and no one felt like taking the risk.

Several legends about that hanging have gone down in history. According to one, as Claudius stood on the scaffold with the noose around his neck, he was approached by Abimal Young, who demanded to know the whereabouts of those valuable papers that Claudius had stolen from him. Presumably he thought that, when faced with imminent death, Claudius would try to redeem himself by showing a little remorse and honesty.

Claudius is said to have replied, "Mr. Young, this is not the time to be talking about papers. Meet me in the next world and I will tell you then."

It is also said that Claudius removed his shoes just before he dropped. When asked the reason for that, as he was otherwise nattily dressed for the occasion, he answered that it was because of his mother. She had predicted that he would die with his shoes on and he wanted to make her a liar.

Whether the poor woman lived to see her prediction fulfilled is unknown. Two of her grandsons followed their father's route. His son James met the executioner at Goshen not long after Claudius had his turn. William was shot during a gunfight in the mountains and was left there to rot. A third son, Richard, tried to take over the outlaw gang. It was soon broken up and he fled to safety in Canada, along with other Tories.

"Gross" Hardenburgh

His given name was Gerard. They called him "Gross," which may have been a Dutch rendition and not because he was so large, though he was. His father was Johannes Hardenburgh

of Hardenburgh Patent fame. Gross, or Gerard, was born in Rosendale, in Ulster County, sometime around 1733. Even in youth he was stubborn and tempestuous, and he took to drink at an early age. It did not seriously affect him until later.

During the Revolutionary War he held the rank of captain in the Continental army. It seemed to suit him. He is remembered as a hero in spite of later acts that stained that reputation. His heroics came about in the course of the attack on Wawarsing in August 1781. The settlement had sent out advance scouts, but they were captured and couldn't warn the colonists that the enemy was approaching. The British attack, therefore, took Wawarsing by surprise. Nevertheless, the colonists rallied quickly and put up a brave fight.

The idea was to capture the town house by house. At each house there was resistance. The enemy, however, numbered four hundred Indians and Tories, and was unstoppable. By the time they neared the stone house belonging to one John Kettle, Hardenburgh was ready for them. He had been visiting the home of a friend one mile away when he received news of the attack. He had only six men with him, but he made the most of his crew. He split his small detachment and approached through the woods so the enemy couldn't see how few they were. As the Indians came closer, he took off his hat, waved it above his head and yelled in a thunderous voice. Never dreaming that there were only seven of them, the enemy scattered.

That retreat did not last long. The Indians quickly discovered that they had been tricked. By then, Hardenburgh and company had reached the house unscathed, even though they were fired upon. He found three soldiers inside. With an axe, they chopped gun ports in its walls—no easy task when the house was made of stone. Firing through them, protected by heavy walls, they managed to drive back all four hundred of the enemy. Thus Wawarsing was saved.

There are people who thrive on danger and excitement. It seems to bring out the best in them. Hardenburgh must have been

of that type. After the war it was all anticlimactic. That was when drink took over, along with the more unpleasant side of his nature. It had to do with land and a dispute over questionable titles. The settlers in the Neversink Valley had every reason to think their titles were clear. They had paid for their parcels of land, made improvements on them, built houses and assumed they could go in living in peace and modest prosperity.

Then along came Gross Hardenburgh, who claimed the land as his own.

Over the years since the Revolution, Hardenburgh had married a nice lady, had several children and been drinking steadily. The drink, combined with his natural temperament, had made him such a vicious, vile person that his own father felt moved to disinherit him. The senior Hardenburgh reworked the terms of his estate so that only the descendants of Gross's wife, Nancy Ryerson, could inherit. Unfortunately for that idea, not only did Nancy die before her husband, but several children died unmarried and without heirs of their own. Thus their share of the estate fell into Gross's hands. He saw it as a vindication. God himself, he crowed, had struck down those children to rectify the changing of the will.

He seems to have had no love for anyone in his family, and certainly no mercy for the inhabitants of the Neversink Valley. He insisted that the land belonged to him and the settlers had to leave. When they refused, claiming that they had clear title, he turned to forcible methods.

It was now the fall of 1806. Many crops had already been harvested and stored for the winter. Hardenburgh confiscated all the growing crops of one James Brush, as well as six hundred bushels of stored grain. He removed the grain to his own gristmill, which was near his home and that of one of his sons. The son also owned a barn where Hardenburgh had stored three hundred bushels of grain he had taken from other settlers.

Soon afterward, the barn caught fire and burned to the ground, as did the mill. So did Hardenburgh's house and that of his son. It couldn't all be coincidence. Furthermore, it wasn't

hard to guess at the reason. No arsonists were ever caught, but several of Hardenburgh's relatives who lived nearby felt that the family was under attack, and moved away.

Gross's behavior took an even more brutal turn. When James Brush still refused to leave, despite having his food supply destroyed, Hardenburgh threw the family out physically. In so doing, he gave Mrs. Brush a violent kick, even though she had very recently given birth and held the baby in her arms. At another home, while the husband was away, Hardenburgh dragged the wife out by her hair. The trauma of this was so great that she died a few days later.

The settlers refused to be cowed. It was all-out war. Hardenburgh became still more vicious and the settlers more determined. In the next two years, increasingly violent episodes took place. Even aging didn't slow him down. He was seventy-five years old, in excellent health, despite his drinking, and still physically powerful. He claimed to weigh 250 pounds. That, distributed over his above-average height, must have made him a formidable monster. He knew it, too, and enjoyed his reputation. To one of the recalcitrant settlers, he boasted that in the next seven years he would "raise more hell than has ever been on earth before."

Soon afterward, he was found lying in the middle of a road, unable to move or speak. At first glance it looked as though he had been hurt falling off his horse, which was found a mile away. Or perhaps he had had a stroke. Those who found him took him to a nearby house and called a doctor, who happened to be Hardenburgh's own son, Benjamin. Despite Benjamin's ministrations, his father died that night. Only then did they find a bullet hole in his coat and a wound on his shoulder. Gross Hardenburgh had been shot.

No one came forward to confess. If any had an inkling who did it, they kept their mouths shut. As soon as the death was announced, great rejoicing broke out in an almost obscene display. Drink flowed. People made up songs to celebrate the event. No one, not even Benjamin, his own son, mourned the passing of Gross Hardenburgh. Nor did they try very hard to find his killer.

A few suspects were held for a while, but no information came forth. Only many years later was there a deathbed confession by someone who admitted taking part in the killing. He still refused to name his confederates.

The Unhappy Servant

In the early days of white settlers, it was not uncommon for a would-be emigrant from Europe to sell himself, or be sold, into bondage. It meant he would work in servitude until the cost of his passage to the New World was repaid. For the lender, it was almost the same as buying a slave. He had free labor for the term of the debt, usually a matter of years. For the indentured one, it was often the only way to a new life.

One such person was a young girl bonded to a wealthy landowner in Greene County. The man owned a thousand-acre farm somewhere between Catskill and Cairo. His servant's tragic end has become so buried in legend, fiction and stories of ghost sightings that some of the details are no longer known. Different versions of the event have been told by people who were alive at the time, by clergy who lived in or visited the area and by descendants of the landowner in question.

Some say the girl was of Scottish origin, and others that she was German. There is consensus that she was young, probably in her mid- to late teens. She seems not to have adapted well to the conditions of her servitude.

In other words, she ran away.

Under the system of indentured slavery, presumably the bondsman or woman was aware of, and agreed to, the conditions. This particular girl, whose name has been lost in time, was sold by her parents to work until she was twenty-one, to pay back the cost of immigration for the rest of the family. Apparently this did not sit well with her and she had trouble accepting her life as a slave.

In the Catskill Mountains, high above Palenville in Greene County. *Courtesy of Library of Congress.*

In one version, she ran away with a lover. This has great appeal for the romantically inclined. In another telling, from a grandson of the girl's master, she simply ran away. With no place to go, she couldn't run far. She took refuge with a nearby family of her acquaintance and refused to go back into bondage.

All agree that the master went after her. He had, after all, paid for her family to immigrate and for that she owed him her services. She had not fulfilled her end of the bargain. It is also agreed that she would not go willingly. He was forced to tie her with a rope. What he did with the other end is not clear. He might have tied it around his own waist. Or, according to some, he tied her to his horse's tail. In any case, it seems the master was on the horse, forcing the girl to walk behind it.

She had trouble keeping up. The ground was rough and rocky, and she tripped. This caused her to fall against the horse, which

caused it to bolt. In so doing, it dragged the girl over rocks until she was dashed to death. The master did his best to stop that mad charge, but the horse was beyond obeying. The master himself was thrown from it with one foot caught in a stirrup. He, too, would have been dragged to his death, except that the stirrup strap broke. He fell clear of the horse, probably dazed, but alive. Despite that act of cruelty, he appears to have had some conscience. He turned himself in and was tried for murder.

Probably there wasn't much contest. The court found him guilty. His family influence was such that the sentence was postponed. The court decided that his life should be spared until he reached the age of ninety-nine years. This, they believed, would make execution unnecessary. In the meantime, as a reminder of what he had done and the hanging that supposedly awaited him, he was ordered to wear a silk cord around his neck to the end of his days.

Though his life was spared, it can't have been much of a life. He spent it in penance and alone, shunned by his neighbors. He must have known what they were thinking. No one could forget his cruel deed—or, at best, his lack of judgment. His own memory was the longest and he refused to die until the appointed time. At the age of one hundred he was overtaken by natural causes.

The horror of that event was such that legends grew around it. People began to hear screams in the area where the girl's death occurred. Some claimed to see a fiery white horse and others a shaggy white dog whimpering among the rocks. Such a dog was known to have been a favorite companion of the girl's.

As for what happened to the debt the girl's family owed, we can only hope that the master, in his remorse, forgave it.

STRANGE MURDERS

Most murders are fairly straightforward. Somebody gets angry and blows away someone else. Even if the motive is more subtle, the average murder doesn't go down in history except as a statistic.

The following four cases are more interesting than average, and so they have become part of history. "Love or Obsession?" could happen even today. Stalking and obsession are as prevalent now as they were then, with an ego gone awry.

The story of the blacksmith is, in its way, pathetic. Regrettably, the motive for that one still holds today when people get carried away with being unmerciful to those less fortunate.

The hex murder at the Stone Arch Bridge is famous for its ridiculous motive. And the Stone Arch Bridge, now with a park around it and a playground nearby, is still there, outside Jeffersonville, for everyone to see.

As for Lizzie Halliday—she was just plain out of her mind.

Love or Obsession?

Jacob Gerhardt tried to be helpful. Or so he said. When Jacob's brother Adam died in 1879, leaving his young widow Mena all alone to manage the farm, Jacob moved in to help her. Jacob had

a wife of his own, though from all reports, the marriage wasn't going well. Mena was not only attractive but also wealthy. Jacob decided that she was the one he wanted. If she would consent to marry him, he promised he would divorce his wife in a minute. Mena was having none of it. Jacob persisted. They quarreled. News reports from that time are vague on what happened next. It must have been serious, for Mena announced that she would have him arrested for assault. Apparently Jacob had made a more favorable impression on the neighbors than he had on Mena. They talked her out of her drastic intentions.

Encouraged, Jacob continued to pursue his sister-in-law. He claimed he loved her. Mena remained adamant. No doubt she would have preferred to manage the farm alone than to have Jacob there constantly hounding her, refusing to take no for an answer. Perhaps it was his very persistence that turned her off. She may have felt he wasn't seeing her as a human being entitled to make her own decision in such an important matter. Rather, he thought she was only an object that he had to possess. His declaration of "love" meant nothing when there was no consideration for her feelings and happiness. All that mattered to him was his own desire. And Mena's money.

The situation grew worse. Jacob followed her one Sunday morning late in 1880 when Mena went to the barn to feed her cows. By then, he was beyond tiresome. Mena told him she was planning to marry a man from Binghamton. The man was wealthy, she said, and the wedding would take place very soon.

Shocked, Jacob replied that she was not going to marry any man but himself. In his fury, he seized a crowbar and struck her, fracturing her skull. Whether she died instantly, no one knows. She may still have been alive and he wanted to finish the job. Or perhaps his rage at being rejected was not yet spent. All we know is that as she lay on the ground, dead or dying, he snatched up a club and beat Mena's head to a pulp.

With his anger finally satisfied, Jacob seemed to realize that he was about to be in trouble. He took off for his mother's house

in Cochecton Center. He left Mena's battered corpse to be discovered by her young son. In horror, the boy ran to his uncle, Adam Bishop. What Bishop found was the body of his sister lying in an ocean of blood, her brains spattered over the stones and fence outside the barn.

The strife between Jacob and Mena was well-known. It didn't take anyone long to come up with a suspect. They picked up Jacob at Cochecton Center, where he promptly confessed. He was arrested and jailed in Monticello, the Sullivan County seat.

While in jail, he came up with an explanation that may or may not have been true. He claimed that Mena had attacked him with a pitchfork and he struck her in self-defense. Perhaps because of that battered head, he was convicted of murder in the second degree and sentenced to a term of eighteen years and some months.

He was a model prisoner. He had never been in trouble before. His own mother testified as to his good character. The authorities reconsidered the verdict and the sentence, and decided that Jacob had acted in the heat of passion. In their opinion, the conviction should have been for manslaughter, rather than homicide. He was released from prison, but didn't stay out for long.

Not more than a year later, Jacob was in trouble again. His good character had snapped and he was arrested for setting fire to his sister's barn. The court records do not say why he did it, but evidently the "heat of passion" didn't help him that time. He was sentenced to twenty-six years in Dannemora, and there he died.

The Blacksmith and the Carpenter

They called him a half-wit. They made fun of him for a handicap he couldn't help. In spite of the taunts, Reinhardt Schmidt did his best to fit in. He had learned to be a blacksmith, a useful trade in the 1890s when horses were a common means of travel.

He set up a little shop near the village of Phoenicia, in western Ulster County.

In a further effort to lead a normal life, Schmidt attempted to marry and have a family. He advertised for a wife, as people often did, but he made the mistake of misrepresenting himself. He was afraid the ladies would not be interested if he described his actual circumstances. Instead, he claimed to be wealthy and said he had an elegant home in the Catskills, which even then was becoming a popular resort area.

It was true, he had a home, but it was a small one attached to his shop. It wasn't elegantly furnished or even really furnished at all. A woman answered the ad and became his wife. Their wedding must have taken place somewhere else, before she saw the home. We can imagine her dismay when he carried her over the threshold into a hovel—or what undoubtedly seemed like one, considering what she had been led to expect. She did not stay around for long, but left him in a week's time and got herself a legal separation, probably on the basis of fraud.

So once again Reinhardt Schmidt was a bachelor. It is likely that episode only fueled the taunts, which never ended. People can be cruel, and back in the 1890s there was little pressure on them to have compassion for the handicapped.

One of his tormentors was John Graham, a carpenter. Probably no worse than the others, the unlucky Graham just happened to be one too many. One day, Reinhardt blew up and shot him. He fired directly into Graham's mouth to silence his teasing. Graham fell dead on the doorway of the blacksmith shop.

There appears to have been no one else around at the time. According to a story in the *New York Times* of April 2, 1897, Graham's body lay in the shop for hours. Probably Reinhardt had no idea what to do with it.

He certainly did know he was in trouble. Passersby found him brandishing his pistol and saying he intended to kill himself. He was foiled in that when they managed to disarm him and haul him off to jail.

We don't know much about John Graham except that he lived in the village of Hunter and must have been fairly young. He left behind a wife and three children.

Hex Murder at the Stone Arch Bridge

In 1892, a farmer named Adam Heidt fell ill with a mysterious ailment. For Adam, this was the final blow. His cows had become sick. He was sure he saw blood in their milk. His crops had been poor that summer. And now this. He ached all over. He could barely take a step, it hurt so much. He was sure he knew the reason why.

Adam and his neighbor, George Markert, also a farmer, had both emigrated from Germany about twenty-five years earlier, had settled in the Upper Delaware Valley near Callicoon and knew each other well. George's first wife had been Adam's sister, Caroline.

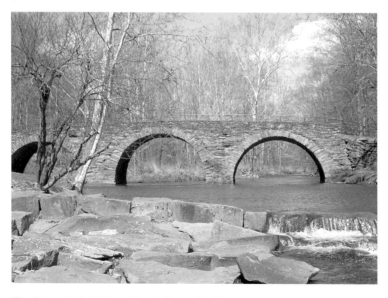

The Stone Arch Bridge. *Photo by James Ryo Kiyan.*

The two men should have been friends. Perhaps they were, for a while, despite their differences in outlook. Like most of their neighbors, George was a modern man, accepting of scientific principles and discoveries. Adam, on the other hand, rejected modern thinking. He was superstitious, narrow-minded and, some said at the time, not very bright. Because of his overwhelming misfortunes, Adam became convinced that someone had cast a spell on him.

Many of the details in this case have become lost or distorted over time, making it hard to know what is fact and what is folklore. According to some, at one point George patted Adam on the back, perhaps to reassure him that there was no animosity, at least on his side. Coincidentally, that was when Adam's physical pain began. He claimed it was three short pats. As everyone knows, three is a magic number. What was more, no doctor could find any physical cause or any cure for the pain. That proved it was a spell. Or a curse. As if further evidence were needed, when George went away for a while (where he went and for how long is not recorded), the pains miraculously vanished. And when George returned, so did the pain.

Adam had two sons. They were Joseph, who was twenty-two, and John, age twenty. Both young men shared their father's views. Quite clearly, their farm had been hexed. Just as clearly, the hex had to be removed. The only one who could do that was the one who had cast the spell—George Markert.

The Heidts notified George that he must remove the spell, and the sooner the better. They threatened revenge if this was not forthcoming. Poor George must have felt stymied. He knew he hadn't cast any spell and did not know how to remove one. He didn't even believe in them. Really, how could anybody take that sort of thing seriously?

George seems not to have realized how grave the matter was, even though he carried in his pocket a threatening letter from the Heidts. For the Heidts, it was extremely serious. They meant every word of it. They came prepared that January night, armed with a

club and a .38-caliber revolver. They knew the exact route George would take on his way home. He would have to cross a bridge over a wide stream, and there they waited.

The Stone Arch Bridge had been constructed a dozen years earlier, around 1880. It was solidly built and stands today, crossing the east branch of the Callicoon Creek. It was built in the days of horses and carriages and even now remains open to pedestrian traffic, though not to cars.

At least two Heidts waited there, Adam and his elder son, Joseph. When George appeared, they confronted him and probably confused him. They fractured his skull with the club and then fired five shots into his face. They threw his body into the creek.

Someone must have reported him missing. The search took several days, but eventually they found his corpse in the icy water. Suspicion fell immediately on the Heidts. Everyone knew there had been bad blood. Although they denied any involvement, Adam and his two sons were arrested. John, the younger one, came up with an alibi that he could prove, and they let him go. Adam and Joseph were held at the county jail in Monticello.

A letter, still legible, was found in George's pocket. It came from the Heidts and it threatened vengeance. Other evidence turned up when the Heidts' home was searched. A .38-caliber revolver was found in the hay in their barn. It had recently been fired and it matched the size of the bullets that had killed George Markert. Searchers also found several articles of men's clothing that had been washed in an unsuccessful attempt to remove bloodstains.

Joseph then admitted to shooting Markert but claimed it was self-defense. He was convicted of murder in the second degree and served twenty years in Dannemora. Upon release he went back home for a while, then married and left the area. Adam was acquitted, perhaps on grounds of insanity. The judge thought he seemed mentally ill and had him committed to the State Hospital in Middletown. There he died in July 1897.

Even long after the murder, people have claimed to see a ghost walking the Stone Arch Bridge. Few have any doubt that it's the spirit of that gentle, hardworking farmer, George Markert.

Lethal Lizzie

Paul Halliday and Lizzie Brown came from the same community in County Ulster, Ireland. It is said that their families were acquainted. Very likely the two would have known each other, except for the age difference. Paul had grown up and immigrated to the United States before Lizzie was born. Lizzie followed soon afterward. She was three years old when her parents brought her to America. A precocious girl, she married for the first time at the age of fifteen. By the time she met Paul he, too, had been married and widowed and had several children. Three sons still made their home with him.

In the late nineteenth century, when men disdained kitchen work, it was deemed necessary to hire a woman to keep house for a bachelor establishment. To find such a person, the seventy-year-old Paul visited an agency in Newburgh where Lizzie had registered for just such work. Perhaps intrigued by the fact of their homeland ties, Paul hired her on the spot. And so Lizzie joined his household in Burlingham, a hamlet in eastern Sullivan County.

Lizzie was not an attractive person. Most members of the family found her repellant, but something about her caused Paul to become "infatuated," in the later words of his son Robert. He was so infatuated that he married her.

He should have taken more time about it, perhaps done a background check. After their wedding, Lizzie boasted to him that she had killed a previous husband and cut him into pieces. The doting Paul refused to believe her. His adorable bride, he thought, was only trying to shock him. It would seem a peculiar way to tease a husband, but then, Lizzie was unusual.

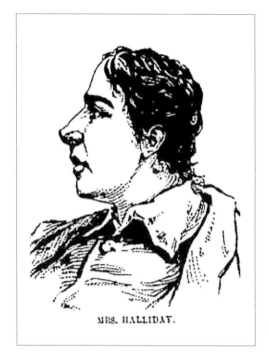

MRS. HALLIDAY.

Lizzie Halliday.
Courtesy of John Conway.

She must have wanted her own spending money, too. According to Robert, she persuaded a Newburgh liveryman—one who kept horses for hire—that she was a poor Irish servant girl who needed to visit her sick mother, and he lent her a horse and buggy. As soon as she was in possession of the rig, she drove it away and sold it to a band of gypsies.

After that came a series of fires. First the house burned, and then the barn. The next to go up in flames was an old mill in which some of the family lived, including a son, John. In that fire, John was killed. Although grief-stricken, Paul explained to his surviving sons that at the time of the fires his wife had been in a "condition peculiar to women" and it always hit her hard. Nevertheless, a fatal fire was a bit too much. Paul had her committed to the Matteawan State Hospital, across the Hudson River.

After she had been at Matteawan for a while, and then another hospital, Paul insisted on having her released. After all, he reasoned, when she wasn't in "that condition" she was perfectly sane. His sons, Robert and Paul Jr., were not so sure she had been cured. They begged their father to leave her, but he refused. He took Lizzie home with him, back to the family farm in Burlingham. For the next episode there were no witnesses except Lizzie herself. We don't know whether Paul had time to realize his mistake. In any case, he disappeared.

With Paul gone and his two sons staying far out of the way, the next time Lizzie's "condition" hit her, she had no recourse but to take it out on strangers. Lizzie found them in Newburgh: a mother, Margaret McQuillan, and her twenty-year-old daughter, Sarah. Whether Lizzie abducted them by force or somehow persuaded them to accompany her to Burlingham is not known. She must have kept them around for a while. After their bullet-ridden bodies were found under a stack of hay in the barn, it was determined, according to one news report, that Margaret was killed on August 30 and Sarah on or about September 2.

A further search of the premises disclosed Paul's body under the floorboards of the house. He not only had been killed, but mutilated in a manner reminiscent of Jack the Ripper, whose rampages in London only a few years earlier were still fresh in people's minds.

For the murders of the McQuillan women, Lizzie was arrested and sent to the county jail in Monticello. There, either her mental illness manifested itself once again, or she put on a good act. She is said to have boasted earlier that by feigning insanity, she could beat the law any time.

Her fame had spread to the extent that Nelly Bly, the legendary investigative journalist of the 1890s, traveled from New York City to Monticello to interview her. Bly tried to get an admission of guilt from the prisoner. It would have capped her story. By Bly's own account, Lizzie turned to the sheriff and asked, "What shall I say, dear?"

When Bly pressed for an answer, Lizzie claimed that her head hurt. "Some other time," she promised. Bly must have been surprised when the other time actually came. Lizzie asked to see her again and, on that visit, gave her life story. She had had six husbands, she said, and later that was verified. Two of them she had simultaneously. She also claimed that she had been drugged by some people she knew, who forced her to watch while they killed not only her husband Paul but the two McQuillan women as well.

Bly reported all this, not as the truth but as what she had been told. Still, many people were skeptical and thought she was only trying to sensationalize. The fact is, it was Lizzie who sensationalized. She went on trial and was found to be insane. Whether she actually was, or was only playacting, back she went to Matteawan. Even there, despite the security, she continued to give trouble. She made the news again when she attacked and nearly killed an attendant. That was the worst but not the only such episode.

Fortunately for the rest of the world, and without Paul to demand her release, Lizzie remained at Matteawan until her death on June 18, 1918.

BODIES IN THE CATSKILLS

In the 1920s and '30s, the Catskills developed a reputation it didn't much want. That was the era of the gangsters. No one minded the gangsters coming and spending their money. They had a lot of it and it helped to enrich the economy. One of their preferred hangouts was the Plaza Hotel in South Fallsburg, an ornate-looking establishment with gracious amenities. The Plaza was a favorite, but not the only hotel they graced with their presence. Some of the gangsters bought property in the area as well.

Besides their penchant for spending money and, even more important, acquiring it, gangsters had a habit of killing one another and anybody else who happened to annoy them. Most murder victims have to be hidden, and that's not always easy. One way of secreting a body is to bury it. The soil in the Catskills is full of rocks, many dumped by the glacier in its travels through the area. That makes digging arduous. Much of the Catskills is forestland and tree roots are hard to break through. No one knows how many bodies are buried in the Catskills. To this day there are probably quite a few that have never been found. Our resourceful gangsters, however, came upon a better and easier dump: the lakes!

Some of the lakes were formed by the glacier, others from streams and springs and some were man-made. However they

came about, the lakes are many. A weighted body can stay on the lake bottom forever—unless something goes wrong, and sometimes it does. Again, no one knows how many murder victims disappeared that way. During the great gangster songfest, which we'll come to in a while, many a final resting place was pointed out to authorities. Many a previously unknown murder came to light. Other corpses remained undiscovered.

The following are some of the more famous discoveries, both in and out of lakes. After that we'll discuss the gangsters themselves, mostly the ones who did their dirty work in the Catskills.

The Saga of Walter Sage

When Prohibition ended in 1933, bootlegging ceased to be profitable. There were other ways, however, to earn a buck and one of them was slot machines. Any hotel or other business that would allow it had slot machines installed. According to the way gangsters operated, probably many business owners who didn't allow it were persuaded otherwise.

Walter Sage, a young Syndicate member in good standing, was assigned the task of overseeing the slot operations in the Catskills. Mostly that consisted of collecting the proceeds and, needless to say, turning them over to the bosses. It was a big responsibility.

After a while, Sage fell from grace. He was suspected of skimming off some of the profits for himself. Whether or not he was given a chance to explain is not known. He may not have realized that he was suspected. When a gang member does wrong, he pays, and that's the end of it.

Irving "Big Gangi" Cohen was one of Sage's best buddies. They had even roomed together for a while. Sage may have thought it was only a friendly gesture that July night in 1937 when Big Gangi suggested they go for a ride in the mountains with another guy, Jack Drucker. Even if Sage had misgivings, what could he say? If they're gonna take you for a ride, they're gonna do it and that's that.

Sage sat in front with Drucker, who was at the wheel. Big Gangi took the back seat. They rode along for a while, admiring the moonlight and the stars, until they reached a dark and lonely spot in the road. Then an arm went around Sage's neck, immobilizing him. Big Gangi had an ice pick. So did Drucker. Again and again they stabbed, riddling Sage's body with thirty-two puncture wounds. According to eyewitness "Pretty" Levine, at one point during the struggle Sage grabbed the steering wheel and caused the car to jump out of control. With that, Drucker's blow went wild. His weapon struck Big Gangi's arm. Big Gangi let out a yell and leaped from the car. His immediate thought had been that the attack was deliberate, that he was next in line to be killed. Drucker, along with Levine and Harry Strauss in the follow-up car, watched him disappear into the woods and shook their heads. Whatever that was all about, they let it go. They had their own work to do.

When Sage was finally quieted, they transferred his body to Levine's car. Changing cars was a common ploy with gangsters, intended to leave no evidence. They changed drivers, too, and the death car drove away, to be abandoned somewhere. That was the usual procedure. The second one transported the corpse to scenic Swan Lake. There they tied it to a slot machine, as fitting retribution. The whole thing was then deposited in the lake, never to be seen again. Or so they thought.

Swan Lake is a popular resort spot and this was the summer season. It must have been a gruesome sight when, ten days after his death, Sage's body rose to the surface, slot machine and all. The killers had everything planned, but made one mistake. They thought they had drilled enough holes to release the gases of decomposition so the body would not gain buoyancy, as drowned bodies tend to do.

Their plan turned out not to be foolproof. According to Burton B. Turkus in his book *Murder, Inc.*, what happened was that those holes were made while the heart was still pumping. That caused the blood to seal off any outlets. The gases accumulated, puffing up the body like a helium balloon.

It was obvious to law enforcement that Sage had been murdered in what was clearly a gangland rub-out. They had no one to pin it on until several years later when the canaries began to sing.

Big Gangi, meanwhile, wasn't taking any chances. He fled all the way to California, where he made the mistake of getting into the movies. He played bit parts as policemen and others, most notably—or noticeably—in the film *Golden Boy.* It was hardly the way to lie low. He was recognized not only by his old associates but also by law enforcement officials, who picked him up and put him on trial. Big Gangi maintained his silence and was acquitted.

The Bridegroom

Sol Goldstein, another minor wheel in that vast organization, was involved with rackets at the Fulton Fish Market. The overlord of those rackets was a relentless tough guy named Socks Lanza. When Socks fell victim to a federal indictment, it occurred to him that Sol might know a little too much about the business. Sol might even be persuaded to talk, and that was no good at all.

Sol, meanwhile, who had broken his mother's heart by leading a life of crime, decided it was time to go clean. He quit the mob and, in the summer of 1936, married a lovely girl, the daughter of an honest man who dealt in used cars. Sol's mother was delighted. The newlywed couple opted to spend their honeymoon in Glen Wild, one of the quieter spots in Sullivan County.

Sol's mother could hardly wait to see them again: her son and his new wife. Soon there would be grandchildren. She expected to hear from Sol, at least a word or two. None came. Much time passed. Mom could stand it no longer. She decided to check on the couple.

It wasn't easy. She had to make a lot of inquiries, chase down a lot of people. Finally she found the bride, but no groom.

The girl said she didn't know much. The only thing she could tell her new mother-in-law was about the phone call. It happened

one evening as they were getting ready to go out dancing. The phone rang. Sol talked a bit and then said he had to leave for a while. He was supposed to meet some people. His wife didn't know what to make of that. They had plans for the evening. Who did he know in Glen Wild, anyway?

He said it was important. It must have been, if he allowed it to mess up their honeymoon. After a while, a car drove up. Sol went out and got into it. That was the last she saw of him.

Sol's mother had to be satisfied with that, but she wasn't. More time passed. It had been several months since the wedding. She couldn't understand it. A mysterious phone call, a mysterious disappearance. What was going on up there in the Catskills?

Unable to rest until she knew what had happened to her son, she made the long journey north to the mountains. She may have taken a train. At that time there were more trains, more railroads, than there are now. Fewer people owned cars and the roads were slow. Many visitors to the Catskills took trains to reach their favorite resorts.

Again she found Sol's bride, who seemed to have made friends and was having a party. That time the girl was able to come up with a little more information. "Sol was thrown into a lake," she told his mother.

The Frenchman

He made a very dapper corpse, neatly dressed in a topcoat and a custom-made suit. His clothes were all wet and he was very dead when they fished him out of Loch Sheldrake, where he was found floating on Memorial Day in 1939. For a while, he remained unidentified.

He, too, had been weighted down, not with a slot machine, like Walter Sage, but with sash weights, the kind used to keep windows running smoothly. From the remnants of rope found around his wrists and ankles, it appeared that his limbs, too, had

been weighted. A number of slot machine tokens were found in his pockets. He had been shot five times, and stabbed. Whoever set out to eliminate him wasn't leaving much to chance.

Finally identified through a label on his clothes, he turned out to be someone the law already knew. He was Maurice "Frenchy" Carillot, a narcotics trafficker. Along with several other people, he had been indicted on drug charges almost a year earlier in Philadelphia. The others showed up but Frenchy never did. He took off and the law hadn't caught him. In his last moments, he may have wished they had.

It was believed that his killer was someone who came from Lepke Buchalter. There were concerns that Frenchy knew too much about Lepke's business, and that meant Frenchy had to go. Lepke didn't like people knowing his business. He didn't trust them not to have a big mouth.

An autopsy determined that Frenchy had been submerged for a number of months. That was borne out by the topcoat. It was the sort of garment a person would wear in the fall, not at the end of May.

Like Sol Goldstein, Carillot had received a phone call. He was asked to go and meet some people, and was told a car would pick him up. Like Sol, and like Walter Sage, Carillot didn't feel he could refuse. It's quite possible that, until the canaries sang, the mob's rank and file may not have known what those summonses entailed. The mob, after all, kept its methods secret, even—or perhaps especially—its methods of murder.

And so Frenchy Carillot, the man in the elegant suit, spent all winter and spring at the bottom of Loch Sheldrake.

The Cabdriver

Lithuanian-American Irv Ashkenaz ran a lucrative taxi business in New York City, with occasional trips to the Catskills. When that business became threatened by mob racketeering, naturally

Irv was concerned. Rather than play along with the mob, which would have cost him money or, worse yet, his whole livelihood, he decided instead to play with the people who were trying to put the mob out of business. In 1936, that meant Special Prosecutor Thomas E. Dewey. Irv knew that Dewey was looking for people who had any information at all on mob activities. Well, Irv had quite a lot, from firsthand experience. With those qualifications, he went to Dewey and started talking.

Irv got carried away, maybe wanted to check a few of his facts. He decided to pay a visit to the Catskills, where the mob also operated, and see if he had things straight. It wouldn't help the cause any if he gave out the wrong information.

That was not a wise move. The mob had ears everywhere. They knew he had talked. They knew when he made that trip to the Catskills. His bullet-riddled body was found half in the taxicab and half falling out, with his head on the ground. The cab was parked near the entrance to the Paramount Manor Hotel at Loch Sheldrake. A sign had been hung above it with the mocking words "Hotel of Happiness."

The Lime Pit

Not much information could be found on a man named Chink Sherman. He is said to have been one of Waxey Gordon's lieutenants. Whatever his role, something apparently went sour in his relationship with the mob. They were a jumpy, paranoid bunch of people. It never took much to bring down their wrath. Chink, or what remained of him, was found buried in a lime pit near Monticello.

At one time, after the demise of Dutch Schultz, there was some conjecture that Chink might have been the triggerman. When the grave was discovered on November 4 of that year, 1935, it was quite evident that this would have been impossible. He had been in the grave too long. He was so well mutilated and full of lead,

not to mention damaged from the lime, that he could be identified only through his fingerprints.

As for his being Schultz's nemesis (which he wasn't), the reverse might well have been true. Earlier in that year, Sherman had imported over $1 million in heroin from Romania. He offered Schultz a share in the profits if Schultz would help him distribute the stuff through his policy operations. Schultz turned him down. He topped the rejection by taking away some of Sherman's restaurant rackets.

That hurt. It cost Sherman quite a lot, and he mumbled something about repaying himself by skimming off a bit from the numbers game. This, of course, did not sit well with Dutch. And that, although unproven, may be how Chink Sherman ended up in the lime pit.

MURDER, INCORPORATED

L awless people have always been with us. Their own interests
supersede those of the community, and certainly those of
humanity in general. Many criminals work alone. Other, more
sociable types form into gangs. They can get more done that
way.

In the early part of the twentieth century, gangs were all over
New York City, especially Brooklyn. They racketeered in gambling,
ran prostitution rings, extorted protection money from business
owners and muscled in on labor unions. They made themselves
rich extracting money from other people. Young boys growing up
in Brooklyn stood in awe of the big shots, the power they wielded,
the women on their arms, their expensive clothes and shiny
automobiles. Such boys would start out as willing gofers for the
men they admired. If they performed well, they were promoted
to greater responsibilities. Gradually they moved up through the
ranks to command their own underlings and possess their own
shiny automobiles.

If they survived that long. Gang life was filled with jealousies,
rivalries and murder.

Still, the criminal way of life went on. Power and wealth were
mighty incentives. It is likely that many of them never earned an
honest wage in their lives or even wanted to. Why struggle year
after year for an income limited by the hour or limited by someone

The Kaaterskill Falls.

else's whim? Not when you had the chance to become a gang boss and have other people working for you, and rake in more money than your laboring father ever saw in his lifetime.

With the passage of the Volstead Act in 1920, huge opportunities opened up for gangsters. Popularly known as Prohibition, the act made it illegal to manufacture or sell alcoholic beverages. It was intended to cut down on drunkenness and the problems that came from excessive drink.

Did it work? Not when people wanted to drink and be convivial. Mostly when you are drunk you don't think about the problems. That's for other people to deal with. Once beer and liquor became legally unattainable, the lawless element wasted no time stepping in to fill the demand. Brewing and all that went with it made its way to the Catskills. There was more room to operate, more secrecy for transportation and a far thinner population of lawmen keeping an eye on things. Besides, it was not too far from the metropolis of New York, maybe a hundred miles or fewer from various parts of the Catskills. And many of the gangsters, like most law-abiding people, enjoyed vacationing there. They knew the area well.

Jack "Legs" Diamond

One of the more notable characters to take advantage of the public's need for suds was Jack "Legs" Diamond. Early in the 1920s, soon after Prohibition began, he established a brewery that supplied New York City with near beer, which was legal. Near beer was "sort of" beer, with an alcoholic content low enough to satisfy the new requirements. At the same time, under the cover of near beer, Legs made the stronger stuff. That he shipped to special customers who kept as quiet as he did about what it actually was.

Legs, originally named Jack Moran, was born in New York in 1897. Like many of his fellow hoodlums, he began his career as a member of a street gang, in this case the Hudson Dusters. During

the First World War, he served for a while in the U.S. Army. Apparently army life was not to his liking. He soon took off for places and activities that he deemed more compatible. It wasn't long before the military caught him, and he served a prison term for desertion.

Jack was always known as a personable fellow, attractive, well dressed and an excellent dancer—but not cut out for a regular, wage-earning type of job. Upon release from prison, he went to work for a gangster called "Little Augie" Orgen. The relationship did not last. Orgen fell victim to the usual gang rivalries. He was engaged in racketeering in the garment industry and Lepke Buchalter coveted that territory. Following gang custom, Lepke had Orgen dispensed with. In the course of that action, Legs received two bullet wounds himself, but he survived. Legs had a knack for surviving. Dutch Schultz is said to have despaired at one time, "Ain't there nobody what can shoot this guy so he don't bounce back?"

In addition to the garment industry, Lepke had other operations going. Legs Diamond soon joined him as manager for his bootlegging businesses in the lower part of Manhattan. Again the rivalries cropped up. Dutch Schultz, who bootlegged in Harlem, wanted to expand. That was much of the problem. Hardly any gangster was satisfied with what he had; he always wanted more. Legs Diamond, who also wanted more and wanted to get away from Schultz as well, moved his business upstate and opened breweries in the Catskills.

During Prohibition, while bootlegging gangsters grew wealthy, legitimate breweries suffered and many had to close. One such establishment was the Barmann Brewery in Kingston, which had been in business since 1881. When Legs Diamond took it over, he began brewing illegal beer that he shipped out by way of rubber hoses that ran through the city's sewers. Most of the beer ended up in speakeasies that Diamond also owned.

At one time the brewery was raided by an elite group of federal agents. They seized a number of hoodlums, but never found the

rubber hose pipeline. It was only "discovered" in the 1970s, though long ago, many people knew about it. They kept the information to themselves, with a full understanding of what would happen if they ratted on Legs Diamond.

Even in the Catskills, Legs wasn't safe. He had made a real enemy of Dutch Schultz, who also moved north and never ceased to try to eradicate him. Legs continued to survive each attempt, including the time Schultz's men burst in on a private dinner and opened fire. On another occasion, they tried to machine-gun him outside a hotel in the Greene County village of Cairo. Although two bystanders were killed, again Legs walked away.

He was hardly an innocent party himself. Legs perpetrated his own brand of mayhem. According to a *Time* magazine article dated July 27, 1931, Legs went on trial in Greene County for the torture of a farmer, Grover Parks, who was transporting whiskey for a competitor. Legs strung the farmer up and held lighted matches under his bare feet. He set fire to the farmer's underwear. Three witnesses testified for the state. Five others testified that Legs had been in Albany at the time. The jury acquitted him, which "stunned" Attorney General John James Bennett Jr., who had been appointed by then-governor Franklin Roosevelt to eradicate gangsters from the Catskills.

He should not have been so surprised. Hoodlums had a way of being acquitted or getting off with absurdly light sentences, even in the face of obvious guilt. By and large, luck had nothing to do with it. Mostly it was a matter of "fixing" the judges, the lawyers, the sheriffs and police.

Legs's luck ran out in 1931, in the state capital of Albany. He had been a fixture in that city for some time. He was scheduled to go on trial for one thing or another, and felt sure he would beat the rap, as he always did. He was not so confident about Dutch Schultz, who was still gunning for him. Legs had gone into hiding, but—according to the *Daily News* of December 19, 1931—he couldn't resist just one visit to his girlfriend, a redheaded Ziegfeld Follies dancer named Kiki Roberts.

That was when they got him. Three bullets at close range to the side of the head.

Who was responsible for Legs's assassination remains uncertain. The obvious conclusion would be that Dutch Schultz finally succeeded. There is another version, however, based on a 1974 interview with Dan O'Connell, who had been the chairman of Albany's Democratic Party back in the 1930s. He claimed that Legs had approached him about going into the "insurance business." What that meant, O'Connell realized, was that gangsters planned to move into Albany. If the authorities paid up, the gangsters wouldn't bother anybody. O'Connell knew perfectly well how it worked, and he very much did not want gangsters moving into Albany. He informed Legs of that fact and said he didn't expect to see him around town beyond the next morning. Legs refused to leave, even when threatened by the chief of police.

Legs was probably accustomed to buying police chiefs. This one, a man named Fitzpatrick, was not for sale and did not make idle threats. Legs discovered that only too late. This account of his death was confirmed by other witnesses.

Whether Albany was kept pure of gangster elements, the Catskills certainly were not. Sullivan County became the summer resort of choice for mobsters. It was also a convenient place, with its open land and many lakes, for disposing of corpses. Along with the gangsters came their usual jealousies and rivalries. And murder.

In the early 1930s, some of the top mob bosses decided there was too much murder going on and something had to be done about it. They got together and formed what they called the "Commission," or "Combination." This was also known as the National Crime Syndicate. It united the major mobs under one board, made up of top bosses who all had equal say. No major policy changes could be instituted, no executions performed, unless they all agreed.

Murder was still important, even though it was now to be regulated. Murder was the only way those gangsters knew to protect themselves and their interests. The term Murder, Incorporated is attributed to Harry Feeney, a reporter for the *New York World-Telegram* in the 1930s. Whatever the gangsters called it, Murder, Inc. became an integral and very vital part of their Syndicate. One man, with plenty of brains and no conscience at all, directed most of the murders performed by that outfit:

Lepke Buchalter

He looks genial in his picture. At five feet, five and a half inches, he was not a large man. He had soft brown eyes that belied his true nature. Louis "Lepke" Buchalter was a ruthless and remorseless executioner. He was also a racketeer of enormous power and ambition. J. Edgar Hoover called him "the most dangerous criminal in the United States."

He was born in 1897 into a family of hardworking high achievers. His siblings grew up to be a clergyman, a dentist, a pharmacist and a teacher. His parents loved him and called him "Lepkeleh," a Yiddish nickname for Louis. It was shortened to Lepke, which stuck with him all his life and beyond.

With such a comfortable beginning, how did Lepke turn out the way he did? These days, like many gangsters, he might be called a sociopath. Many people have opinions on how such a character disorder is formed, but no one at this time has fully figured it out.

Lepke's life of crime began on Manhattan's teeming Lower East Side. There, as a youthful street gang member, he perpetrated such mischief as burglaries and robbing pushcart vendors. At that time, many European immigrants, lacking the capital to rent actual stores, earned their livelihood selling goods on the street from pushcarts. It was during one of those ventures that Lepke met Jacob Shapiro, a youth of like mind. It could have been a disastrous encounter: they were both trying to rob the same

Lepke Buchalter. *Photo courtesy of John Conway.*

pushcart. Instead of clashing, however, the two became lifelong friends and business partners.

Lepke's early career had its ups and downs. By the age of twenty-two, he had already served two prison terms for burglary. Prison was meant to punish, not to reform, and Lepke did not reform. Upon his release, he was ready for the big time. He and Shapiro

found a convenient outlet for their talent in the clothing rackets. They worked both sides of the garment district, skimming funds from the unions and extorting protection money from the business owners. Lepke had a way of being soft-spoken and persuasive. He was rarely known to lose his temper or raise his voice. A man with a reputation such as his didn't have to shout. No one, not his associates, his underlings or his victims, dared cross him. As one of his soldiers once put it, "I don't ask no questions, I just obey. It's more healthier."

Lepke, with his gentle looks and ruthless methods, rose in power to become one of the top crime lords in the country. He sat on the board of the Syndicate. He had an army of enforcers to impose his will and keep his operations running smoothly.

Lepke was responsible for a number of submerged bodies in Sullivan County's beautiful lakes. Not that he dirtied his own hands with such activities. He had his minions take care of those matters. But Lepke ordered it done and planned it carefully so that nothing could be traced back to him. In 1936, Lepke ordered a killing that would eventually undo him.

Joseph Rosen had been a truck driver for the garment industry. He had worked his way up to a decent living, gaining new routes, some as far away as Pennsylvania. Then Lepke came along, eager to get his hands on the trucking business. By means of a threatened strike, he took away Rosen's Pennsylvania routes and left him out of work.

Lepke promised that Rosen would be taken care of. The care was not forthcoming in sufficient volume to sustain life for Rosen and his family. When Rosen complained, Lepke set him up with a small candy shop in the Brownsville section of Brooklyn. The shop did not do well. Rosen again complained, reminding Lepke of his promise. This time Lepke gave him a sum of money and told him to leave town. Not only that, Rosen was to keep his mouth sealed. Rosen left for a while, but returned when his wife became ill.

This was the time when a special prosecutor, Thomas E. Dewey, was taking a deep look into organized crime. To do that,

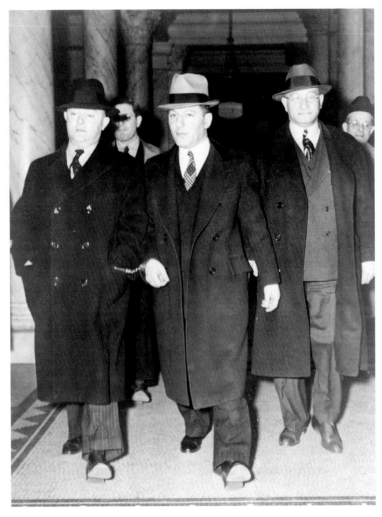

Lepke in company with J. Edgar Hoover. *Courtesy of Library of Congress.*

he needed people who were willing to talk. The mob code of silence kept most of them quiet, but Rosen was not a member of the mob. He thought he could gain leverage by threatening to go to Dewey and tell all. He should have known Lepke.

It was the first and last time anyone saw Lepke lose his temper. He had kept his businesses healthy all those years by maintaining a cool exterior. He never let anyone hear anything that might compromise his operations. That time, he snapped. Rosen's threat so enraged him that he blew off in front of his trusted aides, Max Rubin and Allie Tannenbaum.

"That son of a bitch Rosen!" Lepke screamed. "I'll take care of him."

Max and Allie were to remember those words on a Sunday morning soon afterward when Rosen was gunned down in his candy shop. They knew exactly what had happened, but didn't say a word.

As the Dewey investigations heated up, Lepke took preemptive action. "No witnesses, no indictment," was his motto. Bodies began dropping everywhere. In 1937, Lepke went into hiding. From wherever he was, he continued to put out contracts. He had his own staff of killers and they were busy.

So were the feds, searching for Lepke's hiding place. The search grew nationwide and even worldwide, as reports of sightings abounded. They posted a reward of $50,000. In those Depression times, it was a lot of money. Even so, no one squealed. Hardly anyone, in fact, knew where Lepke was. He had always been discreet. Some of his more flamboyant associates couldn't help enjoying a certain amount of notoriety for their exploits. Not so Lepke. It was safer that way.

He grew a mustache and wore dark glasses. His face was unremarkable in any case. With the disguise, no one even noticed him, especially as he remained in the last place the police thought of looking. For two years they searched, turning up every rock. All the time, Lepke was right there in Brooklyn.

The feds wanted him on a narcotics charge. If convicted, he could serve ten, maybe fifteen years at the most. New York, however, was another story. Under Thomas Dewey, the charge was murder. The birds were singing, most notably Abe Reles (we'll have more on him later). Besides, there was that outburst overheard by several people, the one about "taking care" of Joe Rosen. For that, Lepke could face the electric chair.

He might have stayed in hiding, but it wasn't so safe anymore. His own mob associates urged him to surrender for the good of the Syndicate. If Lepke were locked up, it would take some of the scrutiny off the Syndicate methods and secrets. Those must be protected at all costs, even if it meant the sacrifice of any one person.

Lepke knew he had few friends left. There was only the kingpin, the mob boss, Albert Anastasia. And Moey Dimples, Lepke's trusted lieutenant. Moey was in charge of the East Coast gambling operations and they were being looked into most intensely. He didn't want to lose his livelihood.

In August 1939, Moey told his boss the problem was solved. "We've got a deal," he announced. "Turn yourself in to the feds and you're safe from Dewey."

Lepke knew that sooner or later someone would close in and take him. It was inevitable, and this seemed the easier way out. Anastasia urged caution. "What's the hurry? You can go in anytime. But as long as they ain't got you, they can't do nothin'."

Lepke had made up his mind. He sneaked out of hiding as quietly as he had sneaked in.

The quiet didn't last. Waiting for him as he changed cars were noted columnist Walter Winchell, and J. Edgar Hoover, chief of the FBI. Now that they had Lepke in custody, Hoover broke the news. There was no deal. Lepke had been set up.

He was tried on the narcotics charge and sentenced to fourteen years in Leavenworth. That was nothing, however. They really wanted him for murder. Dozens of murders, but the one that promised the most success was Joe Rosen, and that only because

Lepke blew his temper in front of witnesses. Lepke fought hard against extradition. In the end, he lost. He was extradited to New York, tried and convicted of homicide.

He spent his final days in Sing Sing prison. At the last minute, so the story goes, Lepke decided to talk. And they were willing to listen. Several officials drove up from New York City to meet with him in the Death House. This could be their big break.

It wasn't. Lepke talked, but said nothing of any import or much of any interest. He named no names, which was mostly what they wanted. Lepke had a sharp mind. If he really thought he could save himself by throwing them a bone with no meat on it, he was mistaken.

At 11:00 p.m. on March 4, 1944, the man who had ordered so many executions was himself sent to the electric chair.

Jacob Shapiro

Unlike most of his fellow gangsters, who were either Sicilian- or American-born, Jacob Shapiro entered the world by way of Odessa, Russia, in 1899. He was only a boy when brought to the United States, and barely a teenager when he teamed up with Lepke Buchalter.

Jacob was a big hulk of a man who had a way of roaring when he was angry. He would yell, "Get out of here," and it sounded like "Gurrah da here." He did it so often that his nickname became "Gurrah." From early on, he was known as Gurrah Shapiro.

Together he and Lepke went into labor racketeering. They saw their chance with the fur trade. The majority of those in the business were united under two separate organizations: the Protective Fur Dressers Corporation, made up of the largest rabbit dressing companies, and the Fur Dressers Factor Corporation, consisting of companies that dealt in non-rabbit furs. Each corporation had amalgamated with the purpose of eliminating all competing firms that refused to join them, and

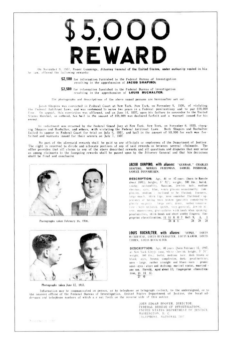

A wanted poster showing Lepke and Gurrah. *Courtesy of Library of Congress.*

to punish dealers who did business with nonmembers. Those who resisted were given anonymous warnings. If the resistance continued, their factories were subjected to explosives and stench bombs and their goods were destroyed by acid. This was kept up until either they capitulated or were forced out of business.

Lepke and Gurrah were hired as enforcement managers. They worked out the strategy, but had others under them do the actual dirty work. Their hired thugs used a variety of methods, not only bombs and acid, but also assaults, kidnappings and arson.

From the fur trade they moved on to bootlegging and rackets. All their lives, right up until the big crackdown, they were a team, with Lepke as the brains and Gurrah as the brawn. When Lepke opened his operations in the Catskills, Gurrah was there, helping. When the crackdown came, they were both imprisoned, although they met different fates. Lepke, as we know, went to the electric chair. Gurrah was handed a sentence of fifteen years to life.

Waxey Gordon

Like most of the others, Waxey started out as a youthful street punk. Born Irving Wexler sometime in the late 1880s, he was so successful at picking pockets that people commented it was as though the wallets were coated in smooth wax. Hence the nickname.

From "dipping," Waxey graduated to being a labor goon, enforcing the will of the mob. For that he was well suited, with his large frame and tough-guy visage. Finally, with rumrunning, he became a wealthy man. His empire included trucks and ships as well as several New Jersey breweries. He married a rabbi's daughter and had a family, whom he endeavored to keep separate from his business activities. Undoubtedly they were content, living in a luxurious ten-room apartment on Manhattan's Upper West Side. In addition, there was a house on the New Jersey shore and vacations at White Lake in the Catskills.

Waxey's rented Catskill lodge became a convenient hideout, not only from rival gangsters—he had a long-running feud with Meyer Lansky, who had allegedly hijacked some of his beer-filled trucks—but also from government agents. The feds were after him for income tax evasion, a tried and true method of nailing gangsters who were too slippery to be caught for their other crimes.

As a precaution, Waxey kept two bodyguards with him at the Catskills house and, for a quick getaway, a speedboat moored at the lake's edge. Despite all this security, the feds got wind of his presence. They kept the place under surveillance all one night and, in the morning, surrounded it. His two bodyguards were quickly subdued without putting up resistance. Waxey was even easier. They found him asleep in bed. They took him to New York, to the utter pleasure of special prosecutor Dewey. After a lengthy

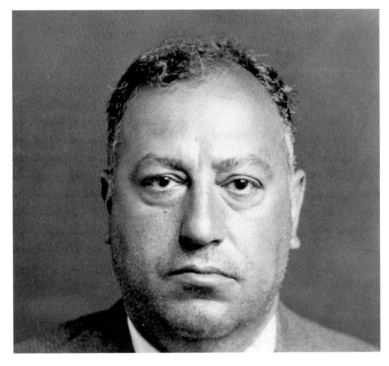

Waxey Gordon. *Courtesy of John Conway.*

grilling, investigation and a ten-day trial, Waxey was convicted and sent to Leavenworth.

The trial received much media attention. With that, it couldn't help but blow apart the shield Waxey had tried to keep around his family. It did so in a particularly tragic way. His son Theodore, a pre-med student, set out from his North Carolina school to plead for a lenient sentence for his father. It was sleeting that day and the roads were slippery. Theodore never made it to New York. As if his death were not enough, or perhaps in part because of it, Waxey's marriage fell apart.

He served his seven years in Leavenworth and, upon release, found himself alone and desolate. Even his old gang had dispersed, its members either dead or joined up with other mobsters. He

needed to reinvent himself and start again. With that came his well-known announcement: "Waxey Gordon is dead. From now on it's Irving Wexler, salesman."

He moved to San Francisco, but couldn't change his stripe. The sales he set up were as illegitimate as any of his previous activities. It was World War II and sugar was rationed. Waxey made money in black market sugar, and even more in the manufacture of drugs, for which sugar was an important ingredient. This eventually led to his arrest on a narcotics charge in 1951, half a century after his street punk days. His heroin business had stretched from coast to coast. So did his subsequent residences. He was sentenced first to Sing Sing prison on the shores of the Hudson River. From there, they moved him upstate to Attica.

As more charges piled up, he found himself back in California, awaiting trial in the federal pen at Alcatraz. There he died of a heart attack in June 1952.

Jacob "Jack" Drucker

Jack Drucker took part in many Catskills murders, including some no one knew about until the opera was underway. It was Drucker who, during the Sage murder, accidentally stuck Big Gangi in the arm and sent him on his way to Hollywood. Drucker was also involved in the Sol Goldstein and the Frenchman murders. Knowing he had been named by his fellow hoodlums, he decided it was prudent to disappear.

For three years the FBI looked for him. Finally they found him in Wilmington, Delaware, and at last brought him to justice. In 1944, he went on trial in Monticello. Convicted of second-degree murder, he was handed a sentence of twenty-five years to life. In January 1962, he died at Attica prison.

Abe Reles

Brooklyn-born Abe "Kid Twist" Reles was the man who blew wide open the secrets of Murder, Inc. He was responsible for sending many of his fellow mobsters to prison or the electric chair.

In the 1930s, Brooklyn was a hotbed of murders. Bodies showed up everywhere, shot, burned, axed and ice-picked. They were left in cars, in gutters and in empty lots. Some never came to light.

In 1940, Brooklyn District Attorney William O'Dwyer tried to put an end to the killings and racketeering. For a while, the investigation went nowhere. Nobody was talking. That was the mob code and, for most, it was not a matter of honor. It was self-protection.

The silence broke when several birds, in prison on minor charges, began to sing. The first one, Harry Rudolph, sang out of revenge for the mobsters having killed his friend, Red Alpert. When that small crack opened, the arrests began. Many hoodlums were picked up and held on vagrancy charges while the authorities sought to break them down and get everybody for murder.

Under such pressure, a few of the lower-level hoods started talking. For the first time, authorities in Brooklyn and Sullivan County learned that the Catskills had been a favorite dumping ground. It was inevitable. The Catskills were where the hoods vacationed and where they kept a network of slot machines, the operation that led to the death of Walter Sage.

Now the upper levels began to worry, afraid they might be fingered with some solid testimony that could get them convicted. They were, as the saying goes, between a rock and a hard place. Or, more specifically, between the law and the mob. As we know, under mob code, talking was more than likely to incur a death sentence and the death, as often as not, was far from peaceful. In the hands of the law, there was comparative safety: possibly a prison sentence, but rarely death. The biggest hoodlum and the loudest canary to take advantage of this truth was Kid Twist Reles. He took the initiative and turned himself in on a

vagrancy charge. It was a preemptive action, out of fear that Harry Rudolph might implicate him for the Red Alpert murder, or just about anything else. There was plenty to choose from. Abe Reles was a real shortie, only five feet two, but stocky, with long arms and very strong hands. His eyes were sharp and dark, his brows heavy. He had the physique of an ape, but the mind of an elephant. His total recall amazed all who heard him and probably distressed many more. The hard-eyed Kid was a tough and systematic killer. He was often arrested and rarely convicted, except for a few minor transgressions. Several of his acquittals were courtesy of the same "fixed" judge. The mob was known for greasing its way out of legal predicaments.

In January 1940, Kid Twist thought it wise to get himself locked up on the usual vagrancy charge—that is, hanging around on street corners. For a while he remained cocky and convinced that he would soon be out again, back to his former activities. Then something changed his mind. He slipped a note to his wife asking her to arrange a meeting with O'Dwyer. As soon as the meeting took place, Kid Twist began to sing.

His song went on and on. He described each murder in intricate detail, including the exact date, place, method, who was involved in the deathblow and who in the coverup. He provided further information about the killing of Walter Sage, who wound up in Swan Lake, and the Frenchman who was found in Loch Sheldrake. Reles shed light on murder after murder with details that sometimes made his listeners ill.

Of course, such a valuable songbird had to be protected. Reles was placed in the Half Moon Hotel at Coney Island under heavy police guard to keep him safe. For more than a year he remained there, sleeping at night under guard, singing his songs during daylight hours in the district attorney's office and in the courtroom. And then, one morning in November 1941, he was gone.

They found his body on the roof of a hotel extension, six stories below his window. They also found two sheets knotted together dangling from the window, attached by a wire that had come

undone. The guards who were supposed to be guarding him claimed no knowledge of how it happened. The police decided it had to be either suicide or an escape attempt.

That didn't wash with Burton Turkus, author of *Murder, Inc.*, who was assistant district attorney at the time, conducting those investigations. That the body had first landed in a sitting position was ascertained by its fractured spine. It was too far out from the window to be a simple drop. Turkus was sure he must have been pushed, or thrown out, although how the killers got into the room was a big question. Reles was known to be a pain in the neck, often playing clumsy practical jokes on his guards. They disliked him intensely—but enough to abet in his death, especially when he was so valuable to the investigation?

No one learned the answer then, and probably no one ever will. It happened back in November 1941, just a month before Pearl Harbor. Since then, too much time has passed and the whole cast of characters has gone to its reward.

"Dukey" and "Pretty"

Before Reles, it was two young, low-level mobsters, Anthony "Dukey" Maffetore and Abe "Pretty" Levine, who started the chorus of songbirds. Dukey was tricked into beginning the aria when he was arrested on a murder charge in 1940. With Dukey in captivity, lawmen had what they had long awaited: a foot in the door. They managed to convince the young man (with perhaps a grain of truth) that his associates in the Syndicate planned to have him killed. He was better off talking to them instead.

Dukey was a bit slow in many matters, but he did know what would ensue if he squealed on the mob. It took a while to break him down, but finally he came to believe them. And he began to talk.

What they really wanted was Pretty Levine, who had a sharper mind and could probably fill in more details. Pretty—so called

because of his curly hair, big blue eyes and dimples—had been a mobster since the age of thirteen. Eventually he tried to leave the mob, but was sucked back into it when he had to borrow money to get his wife and their new baby released from the hospital. Like Dukey, he refused to talk. The DA's office had greater leverage with him because of his family. It was for their sake that he insisted on keeping quiet. As a desperate move, the authorities put his wife in jail. Since he had revealed to her some details of a murder, they said it made her an accessory after the fact. It was she who finally persuaded Pretty to talk. She felt safer with the law than with the mob, who probably wouldn't believe that Pretty hadn't talked, and would assassinate him anyway.

Together, Dukey and Pretty described the many murders in which they had participated, including that of Walter Sage. It had been Pretty's job to drive the follow-up car, with Harry Strauss beside him. Harry was to help dispose of the body. Pretty tailed the first car and parked behind it when it stopped. He couldn't see what was going inside the first one, but he probably suspected. He was hardly a novice in those activities.

He saw Big Gangi fly out of the car and into the woods. The remaining thugs wondered at that, but they were busy. To cover their tracks, they transferred Sage's corpse to Pretty's car. That was the custom in such matters. Often one or the other car would be stolen for just that purpose. The gentleman planning the operation would tell one of his underlings, "Get me a car." He would specify what he wanted: black, four-door. If several hoodlums were involved, the getaway car had to have four doors so they could all pile in quickly, with no hassle. Usually a stolen license plate was added to the mix. Pretty testified that he was paid one dollar for his assistance in that murder. It was Pretty who, several years later, spotted Big Gangi in a ringside seat during one of the bout scenes in *Golden Boy*.

To get further details, the Dukey and Pretty team was given a lift to Sullivan County. There, sheriff's deputies and state police drove them around the county while they pointed out where

various bodies had been dumped. The two had also assisted in the demise of Sol Goldstein, the newlywed who left his bride to go out and "meet some people." Harry Strauss, otherwise known as "Pittsburgh Phil," was in on that one, too. Not only was there the fish market problem, but Harry also had personal issues with Sol. This involved a woman who had once been Sol's girlfriend but later was Pittsburgh Phil's. He must have thought he could erase her past by erasing Sol, and thus give her a clean slate.

To do whatever he had to do, Pittsburgh Phil wanted Sol alive. When Sol got into the car that his wife had seen from the window, he sat in the back between Dukey and Pretty. After they had driven out of sight, Dukey grabbed Sol in a chokehold and Pretty struck him with a hammer. Then they delivered him to Pittsburgh Phil Strauss.

When Pittsburgh Phil had finished with him, they tied up Sol with a blanket and a rope. Dukey and Pretty took him to Loch Sheldrake, where Jack Drucker and Allie Tannenbaum had a rowboat ready. The two rowed their package out to the middle of the lake and dumped it. Despite all that evidence, the state police never could find the body of Sol Goldstein.

Being on the lower rungs of the mob, Dukey and Pretty didn't know all the secrets. After they talked, however, Abe Reles began. He was higher up in the gang and had that fabulous memory. Gradually Murder, Incorporated began to unravel.

Because of their cooperation, even though it took a while, the two young men were given a suspended sentence. Amazingly, they were not even assassinated for all their hard work.

Pretty seemed to fade from public view. Dukey after a while joined another gang whose specialty was auto theft. In October 1950, the thirty-seven-year-old Dukey was arrested for grand theft auto. He was scheduled to appear in Queens County court on March 7, 1951.

Instead, he vanished. After his arrest, the police announced that they had recovered twenty-five stolen automobiles. On that basis, the conjecture was that Dukey's gang might have feared he

would tell on them, and he was therefore rubbed out. It's only a guess. No one knows for sure, except perhaps a few on the shady side of the law. And they will never tell.

Albert "Allie" Tannenbaum

He was also known as "Tick-Tock." Born in Nanticoke, Pennsylvania, in 1906, he was three years old when his family moved to the Lower East Side. The next stop after that was Brooklyn. Spending his early years in Brownsville, Allie was no stranger to punks. Nor they to him. He may not have given them much thought until his teen years. By then his father had become a hotel owner in the Catskills, and Allie worked for him.

The mobsters were frequent guests at that resort, the Loch Sheldrake Country Club. Allie was twenty-five when he first met Gurrah Shapiro. Despite his big, tough exterior, Gurrah seemed personable and was friendly toward the young man. Through him, Allie met other punks, who spent money freely and often invited him to join them in their revels. He was impressed. He had very little money of his own. When they offered him a job, he eagerly accepted.

That was when Lepke was muscling in on the clothing industry. Allie hired on as part of the enforcement team, slinging bombs and acid and beating up anyone who required it. From enforcer, Allie moved up the ladder to become a paid killer. He was valued in Lepke's outfit, not only as a strong-arm, but also for his knowledge of Sullivan County, especially its lakes. With the gang, he had a good thing going. He could spend his summers in the mountains and his winters in Florida, where he kept an eye on the gambling concerns.

He was married, a father and happily ensconced in the crime business when the canaries began to sing. Hearing that Pretty and Dukey were talking, Allie thought it best to make himself scarce. He was visiting Bug Workman, trying to arrange for financing to

leave town, when some detectives stopped by. From the law's point of view, that visit was fortuitous. It was the same day that super canary Kid Twist Reles had named Allie as a person of interest. He was taken in and urged to join the chorus.

Like the others, he resisted at first. For six weeks he held off, in spite of all the implicating testimony from the other birds. He had been right there on the scene, for instance, helping out in the Irv Ashkenaz murder.

Eventually his resistance was worn down. He testified, among other matters, in Lepke Buchalter's trial regarding the murder of Dutch Schultz. He gave evidence in yet another trial and, despite all that testimony, escaped with his life. He died in 1976.

Dutch Schultz and His Hidden Treasure

Although he gained fame as Dutch Schultz, his real name was Arthur Flegenheimer. He was born in Manhattan in 1902, and grew up in the Bronx. When Arthur was a young teen his father left the family, either by death or desertion, depending on who tells the story. Without his father onboard and his mother helpless, Arthur claimed, he left school so that he could support her.

His method of support was to hang about with gang members and engage in petty thievery. At seventeen, he was caught breaking into an apartment. For that bit of mischief, he served his first and only prison sentence, and quickly learned that in the future he must be more careful. He was soon back on the streets "supporting" his mother.

At about that time, he became Dutch Schultz. It was not an original name. It belonged to a deceased member of a rival group, the Frog Hollow Gang. The original Dutch Schultz had been known for his toughness. Arthur liked the reputation associated with the name. Certainly, too, it was catchier than Flegenheimer.

With Prohibition, like most of his fellow mobsters, Dutch went into the bootlegging business. In that, he partnered with another

gangster, Joey Noe, who became his best friend as well as business associate. The partnership ended in 1928, when Noe was shot to death. It is believed that this was ordered by Legs Diamond.

Running a beer business during Prohibition was not always easy going. Dutch pretty much had Harlem and the Bronx locked up as his own territory. Vincent Coll, who operated farther south in New York City, eyed Dutch's monopoly with envy and demanded a piece of it. Dutch said no. That got Coll angry. He retaliated by hijacking Dutch's trucks. With that, war was declared and went on for several years. The body count could only be guessed at. Hostilities concluded with the assassination of Vincent Coll.

Dutch himself became known as a ruthless killer. After Noe's death, he was able to take over most of the New York numbers rackets. In 1932, he was approached by a man named Otto Berman, who offered to help in the enterprise. Otto claimed that he could go to the tracks and fix it so that the parimutuel totals would hardly ever add up to match any numbers that had been heavily played. Dutch, skeptical that anybody could do that, turned down the offer. After some thought, he changed his mind. When Berman paid a second visit, Dutch took him on. Together they made history. Otto Berman was as good as he claimed, and Dutch raked it in by the millions.

While Prohibition was in force, Dutch established a bootlegging business in the Catskills. There was plenty of space in those mountains to operate secretly and a nice network of roads for transportation. He owned several stills in Ulster County, near Phoenicia.

Dutch had never had much liking for Legs Diamond. He felt certain that Diamond was responsible for the death of his old pal, Joey Noe. Now the two were once again butting heads when it came to the trucking of goods produced by their stills and breweries. Most of the truckers carried weapons. Gunfights would erupt along those mountain roads. This went on until Schultz—or someone—finally put an end to Legs Diamond.

With the repeal of the Volstead Act in 1933, Prohibition ended and so did the bootlegging opportunities. Mobsters, however, being adaptable folk, were not left destitute. They still had the numbers, which was always a lucrative occupation. In addition, Dutch Schultz went into the labor union business. He took over several unions, mostly in the food trades, and sent his goons to intimidate and shake down the restaurant owners.

By the time the big gang bosses—Lucky Luciano, Joe Adonis, Meyer Lansky and others—united to form the Syndicate, Dutch was important enough to be asked to join them. He did, but he never really fitted. He didn't much want to. The Syndicate was all about mutual cooperation. Dutch had his own ideas, which he kept to himself. His main interest was in planning the advancement of Dutch Schultz.

Prohibition was over but Dutch maintained a lair in the Catskills, even as he operated his rackets in New York City. The mountains were a pleasant place to hide and relax, if Dutch Schultz was capable of relaxing. He may have had trouble with that when the up-and-coming U.S. attorney, Thomas Dewey, began looking for ways to put organized crime out of business.

Syndicate operations were so convoluted and obfuscated that it was hard to follow the threads. One sure way of getting the big guys was through tax evasion. Mobsters don't pay taxes on most of their income. To do so would reveal too much. It would also cut into their profits. How to get around that situation put the gangsters in a bind.

Dutch had real reason to fear conviction and imprisonment. He knew that while he was incarcerated, other gangsters would take over his turf and he would end up with nothing, as had happened to Waxey Gordon. Lucky Luciano, in fact, was waiting to do exactly that. To save his interests from such a fate, Dutch came up with a drastic scheme that ought to solve everything: Dewey had to go.

That idea appealed to only a few of the Syndicate members. Most thought it would blow open a hornets' nest of judicial

crackdown. As Lepke put it, "We will all burn if Dewey is knocked off." Lepke stood by his own solution: knock off the witnesses instead.

Dutch had a reputation for being especially ruthless and perhaps a little bit crazy. He continued to insist that Dewey must be killed. If everyone else was too scared, he would take care of it himself. No way. They felt sure Dutch was engaging in tunnel vision, just not considering the consequences. A Dewey rubout would affect them all. If he persisted in this madness, then for the sake of the Syndicate and all its operations, Dutch himself would have to go.

That task was handed to Lepke Buchalter and his Murder, Incorporated enforcement arm. Lepke assigned an execution squad of two: Charles "The Bug" Workman and Mendy Weiss. Manning the getaway car was another punk named Seymour "Piggy" Schechter.

Bug Workman was a product of the Lower East Side. He rose up through the ranks of gangsterdom to become a star member of Murder, Inc., much in demand for his services. He looked every bit the part—large and heavyset, with fierce, dark eyes. Allie Tannenbaum once referred to him as "one of the best killers in the country."

Mendy Weiss was said to have been the actual triggerman in the Joe Rosen murder. He was later convicted of that and went to the electric chair at the same time as Lepke Buchalter and Louis Capone (no relation to Al) on March 4, 1944.

The gunmen knew where to find their target. Dutch was a habitué of the Palace Chop House on East Park Street in Newark, New Jersey. The Chop House, in fact, allowed him to use a back room as his headquarters. He held his staff meetings there, and undoubtedly made his presence worthwhile to the restaurant owners.

The date was set for October 23, 1935. The gunmen waited in a nearby apartment until they received a phone call that Dutch had entered the Chop House. With him were Otto Berman, the

numbers genius, and two bodyguards, Abe Landau and Lulu Rosenkrantz.

As the trio of killers approached the tavern, Piggy got cold feet and wanted out. He said he wouldn't know Dutch Schultz if he saw him, and might shoot the wrong person. The others refused to let him get away with that. He had already said he did know Dutch Schultz. On they marched.

According to Jack Friedman, who was tending bar, the door burst open and two men came in. One of them commanded, "Don't move! Lay down." Friedman didn't wait for a second invitation. He hit the floor and lay quietly behind the bar.

The killers went on to the back room, where three men sat at a table. Bug and Mendy opened fire, dropping them all. But none was Schultz. While Mendy fought off the two wounded bodyguards,. who still had enough strength to keep shooting, Bug looked in the washroom. He saw a man standing at the urinal and fired.

Though seriously wounded, the bodyguards were still at it. Bullets zinged everywhere, breaking mirrors, shattering bottles. Bug decided it was time to leave. He soon discovered that Mendy had already done so, taking their getaway car. Steaming, Bug had to make his own way back to New York. According to Paul Sann in *Kill the Dutchman*, Bug was so angry that he lost all discretion and recounted his entire trip to some friends. He ran through a small park, where he threw off his coat, he said. He hid in a "goddam" swamp (his words), slept briefly in a garbage dump and then followed the railroad tracks until he reached the Hudson Tubes.

Dutch, meanwhile, staggered out of the washroom, collapsed at one of the tables and begged for an ambulance. His friends were all as wounded as he. Otto Berman was on the floor in the back room, moaning. Abe Landau, with a severed artery in his neck, had managed to make it out to the street, where he, too, collapsed. Lulu Rosenkrantz lay bleeding on the floor.

Babbling deliriously, Dutch was taken to a hospital in Newark, where he lingered for almost a full day. Police waited nearby with a stenographer, pencil ready, to capture any information Dutch

might reveal. They persisted in asking if he knew who had shot him. He referred to the actual shooter as "the boy." He did not name names. When they asked again who shot him, or ordered the shooting, he only said it was "the boss himself." It is generally assumed that he referred to Lepke.

Other than that, his remarks were cryptic: "I showed him boss; did you hear him meet me? An appointment; appeal stuck. All right mother."

They tried to make sense of that.

At 2:55 a.m. on October 24, Otto Berman died of his wounds. Abe Landau went less than four hours later, at 6:30 a.m. Lulu Rosenkrantz outlived them all, dying at 3:20 the following morning, October 25.

Dutch, meanwhile, had developed peritonitis. His insides had been torn to pieces. His temperature shot to 106 degrees. He called for a priest. Dutch had been born into a Jewish family. From his behavior, it's quite evident that he was not especially pious. A *priest*? His wife was supposedly Catholic, but until that moment any religious fervor he might have had was not in evidence.

They sent in Father McInerney, a priest he knew and especially asked for. At Dutch's request, McInerney baptized him and then administered last rites.

After being lucid enough to make those arrangements, Dutch lapsed again into rambling. He talked about "my gilt-edged stuff..."

Could that mean his money? Over a lifetime of criminal activity, Dutch had accumulated piles of wealth. No doubt he would have it on his mind as he lay dying. But where was it?

Dutch knew that, if captured, he might well be sent to prison, perhaps for a very long time. If so, he was sure the law would confiscate his assets. He saw all lawmen as crooks and knew they would take everything. He especially hated Dewey, who had caused so many of his problems. But he had a solution: what Dewey couldn't find, Dewey would not be able to confiscate.

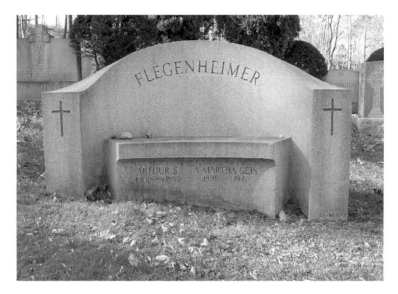

Dutch Schultz's gravestone, showing his real name. *Google image, used by permission.*

Schultz's attorney, J. Richard Davis, let on that Dutch used to keep his spare bills, banknotes and other valuables in a "specially made steel box three feet long and two feet wide." Legend has it that the box was buried somewhere in the Catskills. Estimates place the total value of Dutch's treasure in excess of $7 million. Since his hangout was in the area of Phoenicia, guesses are that the buried trove is somewhere in that vicinity. If it exists at all, it is very safe indeed. To this day, no one has been able to find it, though many have tried.

Dutch Schultz went to meet his maker at 8:35 p.m. on October 24. Having become, at the last moment, a Roman Catholic, he was buried with a small Catholic graveside service conducted by Father McInerney. Before the coffin was lowered, his devoutly Orthodox mother draped it with a Jewish prayer shawl.

With death, he ceased to be Dutch Schultz. On his headstone in the Gate of Heaven Cemetery in Hawthorne, New York, his name is clearly written as Flegenheimer.

The Roundup

For a long time, mob bosses had been smuggling narcotics into the United States. This activity brought huge profits to Legs Diamond, Dutch Schultz and Lepke Buchalter, among others. As those leaders fell, others took over. Business was hampered but didn't stop during World War II, when shipping became difficult. Also, it was nearly impossible to import anything from China, Southeast Asia and other parts of the world involved in the conflict.

By the war's end, the drug trade was in disarray. The laws became tougher and its representatives cracked down. To mob leaders, accustomed to buying protection from the law and from political figures, this was not going to work so well. Other factions, outside of organized crime, were eager to expand that very lucrative business.

In 1956, the U.S. government passed a narcotics law that, among other things, imposed severe penalties for the importation and sale of illicit drugs. That had to be discussed, as did the soaring prices charged by those who imported drugs, notably Meyer Lansky.

Also urgent was the fact that many low-level mobsters were taking it upon themselves to sell drugs on the street. This independence went against Syndicate policy. Such a lack of control could endanger everyone, especially the higher-ups who might be sold out by a street soldier endeavoring to smooth his own arrest.

Those issues were so important that a huge summit meeting was called. With well-known mobsters coming from all over the United States and several other countries, the meeting had to be held in some out-of-the-way location where many could gather away from the eyes of suspicious police officers. What better place than the big spread belonging to Joe Barbara, way out in the Broome County hamlet of Apalachin, New York? The fact that Barbara ran a soda bottling company in nearby Endicott would make a good cover. If anybody asked, the meeting was all about soda distribution.

Hotel rooms were booked, more than a hundred of them. Barbara ordered vast quantities of steak and luncheon meats for the occasion. Big names came from major cities in the United States and from Cuba and Italy. It was a gigantic event—so vast, in fact, that somehow the state police got wind of it, even in obscure Apalachin. Some believe they were tipped off by Carlo Gambino, who would have liked to scuttle the top guys so he could take over everything. Others conjecture that it was Meyer Lansky, fearful that they might decide to eliminate him for charging his outrageous drug prices.

Without a warrant, the police could not actually enter the house. So they waited. They prowled among the cars parked outside and took down license numbers. In addition to police, there were federal agents, probably in civilian clothes. The police themselves wore uniforms and drove marked cars. They couldn't help but be conspicuous. And they were noticed.

Instantly the meeting broke up. Its members fled, only to be stopped and questioned. Over fifty mobsters insisted they had been there for the sole purpose of paying their respects to an ailing Joe Barbara (who was not ailing). It was a story they must have arranged in advance because they all said the same thing and they stuck to it.

Nevertheless, many were brought in, tried and convicted. Unfortunately for law and order, those convictions were later overturned.

Although the raid put a dent in mob operations, it didn't end them. Gangsters continue to operate even today. Crime families may change personnel, but they are still active. There are occasional rub-outs, though not as many as formerly. The Catskills no longer serve as a dumping ground, but they have, over the years, played host to many mobsters. Two later ones with ties to the Catskills, whether they liked it or not, were Joe Bonanno and Joseph Tomasello.

Joe Bonanno

He was nicknamed "Joe Bananas," and he hated it. True, he was many things, but he wasn't crazy. Dutch Schultz may have been crazy, and Abe Reles and others. Not Joe Bonanno. He was born in Castellammare del Golfo, Sicily, in 1905. His godfather and some of his relatives there were Mafiosi. It was a way of life not alien to young Giuseppe. It was, however, a way of life distasteful to the rising dictator, Benito Mussolini, who intended to be the supreme and only power in all of Italy. Joe was a student in Palermo at the time Mussolini began his crackdown. He saw the arrests, the imprisonment, the torture and the killing. It was violent and indiscriminate. Some of the victims were Mafiosi, others were not. Anybody could find himself on the wrong side of Mussolini's law. At first Bonanno joined a group of students who opposed the Fascist regime. But the regime had no intention of being opposed. A warrant was put out for Bonanno and others. Seeing that he was outnumbered, not to mention outpowered, Joe decided to leave while he could. He traveled first to France and ended up in Cuba. From there, in 1924, he made an illegal entry into the United States.

Settling in Brooklyn, where he had relatives, young Joe teamed up with some fellow Castellammarese who were in the bootlegging business and also dealt in lottery rackets. Things went well under the boss, Joe Masseria, who recognized the quickness of mind and superior organizational skills of Joe Bonanno.

Then another Sicilian, Salvatore Maranzano, disputed Masseria's position as head of the family. This launched what became known as the Castellammarese War. Violence hit the streets of Brooklyn and went on for four years. It ended with the assassination of Masseria at the hands of Lucky Luciano

and Meyer Lansky, both of whom favored a peaceable union among organized crime factions. Bonanno acquitted himself well, fighting bravely for his boss, until the boss took a bullet that killed him.

With that, Maranzano was in power. Joe Bonanno, needing some sort of livelihood, joined his staff. That didn't last long, either. Maranzano appointed himself boss of bosses of all the crime families, with Bonanno, Lucky Luciano and others under him. Few cared for that idea. Luciano arranged to have Maranzano assassinated. He then reestablished the individual crime families and appointed Bonanno head of one of them.

Bonanno set about to enlarge his empire. He had things going as far away as Cuba in the south and Arizona in the west, as well as big plans for California. His New York underlings complained that he was neglecting the businesses at home.

When Joe Profaci, the head of another family, died of cancer in 1962, Bonanno plotted with his successor, Joe Magliocco, to murder several other bosses and take over their families. They entrusted the job to Joe Colombo, who leaked the plot to the intended victims.

Such back-stabbing behavior went against all the rules. The two were ordered to appear before the Syndicate board and explain themselves, if they could. Bonanno refused. Magliocco did appear and was given a lenient sentence because he was terminally ill. He was deposed as boss of his crime family and replaced by Joe Colombo.

Bonanno was in a squeeze. Not only did the mob bosses insist on talking to him, but so did the federal government, which was looking into organized crime. He was ordered to appear before a grand jury. On a rainy night in October 1964, just before his scheduled appearance, he had dinner with several of his attorneys. As they left the restaurant, he was hustled into a car by three men with their hats pulled low so he didn't recognize them. One of the attorneys gave a shout, but that was cut short by a warning shot.

The kidnappers ordered Bonanno to keep down on the floor. He did so as the car zigzagged through city streets. Only when they were on the Henry Hudson Parkway was he allowed to sit up. Then he recognized his cousin, Nino Maggadino, and Nino's nephew, Peter. Nino's brother Stefano was boss of the Buffalo mob. He was one of the men Bonanno had planned to assassinate. Now Bonanno probably wondered if it was his turn.

The car made its way over the George Washington Bridge and up into the Catskills. There, at a lonely farmhouse, Bonanno was held prisoner for six weeks. After that, they transported him to El Paso, Texas, where he was finally allowed his freedom.

Joe had connections in the Southwest. One of his sons had developed an ear infection and was sent to a boarding school in Arizona, in hopes the dry air would help clear it up. Joe and his wife, in visiting the school, developed a liking for Arizona and bought a house there. When he found himself marooned in El Paso, he called an Arizona friend to come and pick him up.

Some Mafia experts are skeptical of Joe's version about his kidnapping. It seems plausible, they think, that he engineered the whole thing to avoid having to make that grand jury appearance. The law finally did get him and he spent some time in jail. He wrote a biography, *A Man of Honor*, which was how he thought of himself.

Despite his travails, he lived on, mostly in Arizona, and died in May 2002 at the age of ninety-seven.

Joseph Tomasello

Known to his gangster friends as Joe T., Joseph Tomasello was a capo in the Colombo family. The Colombo group ran many different operations: gambling, narcotics, loan sharking, labor racketeering, thefts, larcenies and so on. According to security people at Kennedy Airport, the gang also engaged in thievery of cargo.

As owner of the Anchor Bus Company based in Brooklyn, Joe Tomasello had a $500,000-a-year contract with the Board of Education to provide fifteen buses for transporting schoolchildren. It seems that wasn't enough for Joe. He was convicted in the 1980s, along with Michael Franzese, of a conspiracy to receive stolen goods. Franzese allegedly delivered $100,000 per week to Tomasello as proceeds from their hijacking operation. Michael was sent to a work-release program. Tomasello served a sentence of ten months.

It didn't stop him. In May 1992, he was indicted with several others on charges of racketeering and complicity in five murders. When his co-defendants were rounded up, Tomasello was not among them. For six years he stayed out of sight.

The FBI refused to say how they found him. According to the online *Gangland News*, it was because his son got married. It was July 1998. Agents staked out the Staten Island church where the wedding took place, thinking Joe T. might make an appearance. He never did. So they took a guess and followed an aunt as she drove all the way to Catskill, New York. There they waited—keeping hidden, of course. After a while the son and his new bride drove up. Still they waited. A few days later the son left the house for a while and returned with Joe T.

Agents, along with state troopers, entered the house. Tomasello surrendered with no resistance. By then, he was sixty-five years old. He faced a life sentence without possibility of parole.

Although it had little to do with murder, the Borscht Belt era must be mentioned here as perhaps the best-known part of Catskills history. In the 1940s, 1950s and 1960s, a number of huge resort hotels flourished. The Concord, the Nevele and Grossinger's were among the most famous. There were others, large and small, offering fine food, plenty of outdoor activities and entertainment by star performers. Most of the clientele were Jewish immigrants or children of immigrants from New York City, seeking a place

where they felt at home and could eat kosher meals. Most were of East European descent. Hence the area became known as the "Borscht Belt," borscht being a thick beet soup that originated in Eastern Europe. Many entertainers, especially comedians, got their start at those hotels and went on to Hollywood fame.

The Borscht Belt's glory days lasted for several decades, fading away as the clientele began to feel at home in other places and opted for a wider variety of experiences. Most of the big hotels have been torn down or are awaiting conversion by developers. Even without them, the mountains still abound with bungalow colonies where Hasidim and other Orthodox Jewish people can find summer respite away from the gritty streets of Brooklyn.

Meanwhile, a controversy continues as to whether to allow casino gambling here. This would bring back some of the large hotels. Proponents insist it would provide a much-needed infusion of money as well as work in a depressed rural area. Opponents argue that it would make for pollution and road-clogging traffic. Gambling is addictive, they maintain, and addicts shouldn't be encouraged.

The Concord Hotel, having seen better days. It is now torn down. *Photo by Wikipedia user: Nomp.*

The controversy has run on for decades. Several deals were almost made with Native American tribes. The idea behind Indian casinos is that land was stolen from the Indians and some of it should be returned in areas where the various tribes could earn their own much-needed income through casinos. A kibosh was put on the plans by Secretary of the Interior Dirk Kempthorne. He claimed that Sullivan County was too distant from upstate reservations and the Indians should not have to travel so far from home for their work.

To the Native Americans, that argument seemed weak and paternalistic. Furthermore, it went back on previous government policies, including a statement by the Bush administration (of which Kempthorne was a part), that there was no legal basis for rejecting an off-reservation casino based solely on distance. With his rejection, Kempthorne had made a complete U-turn from that policy, because he personally was opposed to Indian casinos on non-reservation land. It would have, he maintained in his letter of rejection, "far-reaching implications for the remaining tribal community and its continuity as a community."

The Indians feel that they should have a right to make their own decisions as to what is or isn't good for the tribal community. They may appeal that ban, especially if there's a change in administration.

MYSTERIOUS REMAINS

When the victims of Murder, Incorporated were uncovered, either from a lake or a burial pit, most people knew what they were and how they got there. Sometimes, however, a body or part of a body will come to light that can be neither identified nor explained.

The Oldest Courthouse Inhabitant

In searching for a leak at the Sullivan County Courthouse in October 2000, a workman discovered a hidden attic door with double padlocks. Courthouse authorities were as curious as he about what might be in there and gave him permission to break the locks. Behind the door, what they found was a room filled with dusty file boxes.

As might be expected, most of the boxes contained papers, records of old court cases and other official matter. One box held what the workman thought at first was a bowling ball. It turned out to be a human skull. And bones. A complete skeleton. The only other thing in the box was a tab stamped with the date "April 17, 1944," along with the words "referee: Hoyt." The name "Hoyt" was crossed out and "Gray" written in its place.

Neither name meant anything to those who checked. Nor did the date, although someone observed that that was the time of a Murder, Incorporated trial at the courthouse. The trial had been one of those that ended the busy days of Murder, Inc.

But whose bones were they, and what did their owner have to do with Murder, Inc., if anything? No one knew.

The skeleton was examined by Ken Nystrom, an anthropologist at the State University of New York at New Paltz. From the shape of the bones and the condition of the teeth, Nystrom concluded that the deceased was a male Caucasian about twenty to twenty-five years of age. Evidently he suffered from a bad back and had at one time undergone a period of severe malnutrition, but who he was, no one had a clue. Nothing about the bones matched up with any of the case files from 1944.

That skeleton, still unidentified, now rests in the basement of the Sullivan County Historical Society Museum.

Only One Bone

In 2003, Thomas Muldoon, an Ellenville real estate agent, was cleaning up some property he had recently purchased. The house had been abandoned for many years and he was working in the garage, which had a dirt floor. That entailed a lot of cleaning.

As Muldoon dug through the dirt, he came across a bone. It was an isolated bone about fourteen inches long. He showed it to his wife, who was an artist and knew something about anatomy. She identified it as a human leg bone. With that, Muldoon notified the police.

From there the bone went to the Ellenville Hospital for examination by medical personnel. The experts decided it came from a young person in the late teens or early twenties, gender undetermined. But whose was it? And where was the rest of the person? It didn't match any missing persons report, either current or past.

A backhoe finished digging through the garage's dirt floor. No more human bones were found.

Ashes Are Ashes

Veronica Lake, a megastar of 1940s' Hollywood, was perhaps best known for her peekaboo hairdo, flowing blond waves that partially covered one eye. Veronica was forced to sacrifice her waves during World War II. Many women admired and imitated the actress's coiffure, and as they went to work in factories, there was a danger of that long hair being caught in machinery. The flowing tresses had to go.

Like so many brilliant careers, especially in the arts, Veronica's flared brightly and then ebbed away. She ended her days as a cocktail waitress in New York City and died in her early fifties in July 1973. After her death, friends paid for a modest funeral and cremation. Apparently their generosity was not sufficient. In a dispute over payment, Lake's ashes ended up in a Burlington, Vermont funeral home until 1976, when they were released to friends who paid the outstanding fee.

What happened next is anybody's guess. Lake had asked that her ashes be scattered off the Florida coast. Whether this wish was carried out is uncertain. One account has it than an off-Broadway producer saw the urn they were in, liked it and asked to have it. The possessor of the urn was evidently unwilling to give it up. He poured the ashes into a manila envelope and sent those instead, without the urn.

Somehow the ashes made their way to an antique shop in Phoenicia, New York. Whether they are the authentic remains of Veronica Lake is impossible to determine. The shop's proprietor, a great admirer of Lake, celebrated them as such and then returned them to the man who had kept the urn. Neither he nor anyone else knows the truth of their origin. We can only believe, as did the shop owner in Phoenicia. Even a DNA test would come up empty. Ashes are ashes.

MURDER AND MAYHEM IN THE MODERN ERA

E ver since the time of Cain, human beings have been murdering one another. It doesn't take a war or a Murder, Incorporated to bring that on. Whether the cause is anger, greed or revenge, whether the murder is planned or spur-of-the-moment, it goes on happening and maybe always will.

The "Reverend"

Perhaps he really was an ordained reverend, although probably not. If he was, he veered from the usual path of holy men and women. It's true that Devernon LeGrand had a church: the St. John Pentecostal Church of our Lord, established sometime in the 1960s, It was a four-story town house in the Crown Heights section of Brooklyn. More than a church, it was also a shelter, so LeGrand claimed. Those it sheltered were young women, many of them in their late teens, and their children.

LeGrand referred to the women as his "nuns." He sent them out wearing black, nun-like habits to beg for money in the streets and around the area of Grand Central Station. When police had occasion to investigate the town house, they found eleven "nuns" living there and forty-seven children. Nearly all the children

were related, most having been fathered by Devernon LeGrand. It was all part of his method, said the police. He would get the young women pregnant and then threaten harm to them or their children unless they went out to beg for him.

The begging paid off—for LeGrand. With the proceeds from that, and contributions from his devout congregation, he accumulated enough funds by 1966 to buy fifty-eight acres of farmland near White Sulphur Springs in the Catskills. There he established a summer retreat for his followers.

From all reports, it was not a peaceful retreat. Its neighbors constantly complained of rowdy behavior and loud, late-night parties. Occasional gunshots were heard. Furthermore, the premises violated every health code, with filth, clogged plumbing, child and animal abuse. None of it, apparently, was enough to shut down the camp. It remained open year after year until LeGrand himself was shut down. Or rather, shut away.

That effort began in 1975, when the reverend was charged with bribery and the sexual assault of a seventeen-year-old girl. Some of his parishioners must have become disaffected. Two sisters, Gladys and Yvonne Stewart, sixteen and eighteen years old respectively, agreed to testify against him. They assisted in the bribery trial, but by the time the prosecutors began preparing for the rape trial, Gladys and Yvonne had disappeared.

Someone leaked to police that the girls had been beaten to death in the Brooklyn church, hacked to pieces and their remains disposed of in the Catskills. Law enforcement personnel labored a long time to dig up the ranch, but found nothing incriminating.

The winter of 1975–76 passed slowly. In early March, some bones turned up in nearby Briscoe Lake. It was enough to provide legal justification for a search of the Brooklyn church, where allegedly the murders had taken place. There, the police found bloodstains.

Killers often make the mistake of assuming that if they clean up all traces of blood, it cannot be detected. What they fail to understand is that, no matter how thoroughly a place is cleaned,

blood leaves invisible traces that can be brought out with the use of certain chemicals. Luminol, for instance, causes those traces to glow an eerie yellowish green in the dark.

Whatever was used in that Brooklyn church, it produced enough evidence to bring murder charges. Other deaths came to light as well. Among them were two of LeGrand's former wives, one of whom was believed to have been killed and disposed of in much the same manner as the Stewart sisters.

LeGrand and his son Steven, who assisted in the Stewart killings, were both convicted. Steven, the lesser of two evils, received a lighter term. Devernon LeGrand was given a sentence of twenty-five years to life.

A Very Bad Habit

Seth and Ronna Roberts, a couple in their early fifties, lived in Great Neck, Long Island, and practiced law in Manhattan. It was in the Catskills, a hundred miles away, that their lives came to an end.

Seth and Ronna had two grown sons—Adam was twenty-three years old and Ethan was twenty-one. Until the previous year, Adam had been a student at Syracuse University. He was said to be a senior in the school of management. He also majored in heroin addiction, which rapidly dragged him downhill. In 1998, he was arrested at Syracuse on drug charges. Although the charges eventually were dropped, Adam took a leave of absence and never returned to the university.

As most parents would be, Seth and Ronna were distraught over their son's problem. They tried to help, but took a pass on entering him into a dedicated drug treatment program. Instead they sent him to a private physician, who put him on medication. The medication wasn't having much effect. To hurry things up, they decided to take him for a weekend at their vacation house on a mountainside in Woodstock, New York. There, they hoped, without access to drugs, he would be able to "dry out."

They may have been a little naïve. It is not that easy to "dry out" a heroin addict. The craving is a physical thing. It takes over the whole person. Adam needed his fix and he needed it *now*. When his parents wouldn't let him leave the house, he became enraged. Heroin was everything. For a person in his condition, it was more important than family. In an effort to get what he needed, he fought off his parents, stabbing them both with a serrated bread knife. The family's Ford Explorer was parked just outside the house. Adam took off in it and returned to Great Neck.

Once he had his fix, he was able to settle down enough to take stock of what he had done. There would be consequences. He had left two identifiable bodies in that mountain house. It was only a matter of time before somebody found them. Four days after the murder, on November 17, 1999, he drove back to Woodstock.

The bodies hadn't yet been discovered. They were right where he had left them, in the master bedroom. This time Adam was better prepared. He doused the bodies with gasoline, lit a match and fled again in the Explorer.

As might be expected, the fire not only burned his parents but also set the house ablaze. A burning house is quite noticeable. Someone called in an alarm. Once the flames were put out, firefighters discovered the two charred bodies. Although unrecognizable by that time, they were soon identified through tests. And no one thought either the deaths or the fire was accidental.

As for motive, it could have been robbery. If they were at the house, their car should have been there, too, and it wasn't. Adam may or may not have known that the Explorer was equipped with a tracking device. Police traced it to Brooklyn, where it was found abandoned.

But not entirely abandoned. Three men came to claim it and they had the keys. When arrested for possession of stolen property, they were shown a picture of Adam Roberts. They identified him as the man who had given them the keys.

Adam went on trial in Ulster County. There he confessed to the murder of his parents. The rest of the family, including his

grandmother and two uncles, supported him. Through his attorney, they begged for a lighter sentence than the twenty-three years he faced. This wasn't the real Adam, they said. It was the drugs. Adam agreed. "To say I have remorse is an understatement," he told the court, adding that the loss of his parents was worse than any prison sentence.

Still, the sentence may be able to accomplish what his parents could not. Unless drugs are smuggled into the prison, which does happen, Adam will be forced to go cold turkey.

Guest in the Catskills

Dr. Charles Friedgood's crime took place on Long Island. As a result of it, however, he spent much of his life in the Catskills, at the Woodbourne Correctional Facility in Sullivan County. Until his release in November 2007, at the age of eighty-nine, he had the distinction of being the oldest inmate in the entire New York prison system. By then, he had served more than thirty years.

The doctor had an office in Brooklyn, New York. He was there on a June day in 1975 when he received an anxious call from his housekeeper in Great Neck. It had gotten to be one o'clock in the afternoon, the housekeeper reported, and Mrs. Friedgood was still in bed. Because that was atypical, the housekeeper felt moved to investigate. What she found was an apparently lifeless Sophie Friedgood.

Concerned, the doctor closed his office and hurried home. Probably not as an afterthought, he took with him a blank death certificate. A person can never tell when one of those might be needed. Sophie Friedgood did indeed seem to be dead. From that point, things moved fast. Dr. Charles filled out the death certificate, attributing his wife's demise to a fatal stroke. Because Orthodox Jewish custom calls for almost immediate burial, he shipped Sophie's body to her family's hometown of Hazelton, Pennsylvania, where it was swiftly put in the ground.

Then Friedgood set to work. Three decades earlier, Sophie had come to him as a wealthy bride. She still had holdings in securities. Friedgood wasted no time in calling on her stockbrokers, armed with letters authorizing him to trade on her accounts. These had been signed only a few days before her death.

It all happened so fast that the police hadn't known she was dead and already buried. As soon as they found out, it struck them as a conflict of interest that a husband, even with medical credentials, would sign his own wife's death certificate. The district attorney sent his assistants to Hazelton to request that the body be exhumed. To this, Sophie's relatives consented. For a long time they had sensed something not quite right with the marriage. The sudden death, when she was not even known to be ill, only fueled their suspicions.

Sophie may not have confided much to her family, but she herself knew full well what was going on. Somehow she had discovered a batch of love letters and a nude photo of someone she recognized. For eight years, the doctor had been leading a double life with his Danish nurse, socializing on many occasions as though they were husband and wife. To cap it all, she had borne him two children.

Furious, Sophie confronted her husband. He tried to placate her, but she was having none of it. Instead, she placed the evidence in a safe deposit box. Angrily, she decorated the envelope with the word "Whore," written in Hebrew.

After that blowup, Dr. Charles started to worry. He and his mistress made plans to relocate to Denmark. For that he needed money, and he knew where to get it.

When Sophie was exhumed, an autopsy revealed no evidence of a fatal stroke. What it did reveal was that she had been injected with massive amounts of Demerol, which had shut down her system. The needle marks were still visible on her body.

Dr. Charles almost made it. He had already boarded a plane for Denmark with a case full of negotiable bonds and all of Sophie's jewelry. He must have thought his troubles were over. Soon he could be united with his second family, to live happily ever after on

The Woodbourne Correctional Facility. *Used by permission.*

Sophie's wealth. Just in time, a son-in-law alerted the police that an escape attempt was imminent. Authorities pulled Friedgood off the plane as it sat on the runway. Shortly thereafter, he was indicted for murder.

At the trial, he insisted he was innocent. He never wavered from that, even when his grown daughter testified that, during the police search of their house, her father instructed her to hide the damning bottles of Demerol and the used syringe. (Why he hadn't already disposed of those items is unclear.)

The jury didn't buy his pleas. And that is how he ended up in the Catskill facility at Woodbourne, eventually to become the oldest prison inmate in all of New York State.

The Intruder

The summer of 1999 was a hot one in the Catskills. Even in June, eleven-year-old John "J.T." Vogt found his room too sweltering for comfortable sleep. His mother, Barbara, had an air conditioner in hers and so J.T. was sleeping there, in their Eldred house, on the night of June 21.

Suddenly they both woke. It was dark, about 4:00 a.m., although neither one had the presence of mind to look at a clock. All they knew was the sound they had just heard, like a footstep on the stairs. And then he was there, a looming figure in the bedroom doorway. They could barely see him in the faint glow of a nightlight. A man's voice told them he was lost.

Barbara got up to turn on a light. When the man advanced toward her, she backed all the way to her bed and sat down. She offered to give him directions to wherever he wanted to go. "Just please don't hurt us," she begged.

The man had every intention of hurting her. He carried a knife and he used it, slashing her across the face. "F— you!" he shouted. Barbara fought back. He must not have expected that. Nor did he expect J.T., whom he hadn't noticed in the dark. The man

attacked him next, stabbing and slashing, cutting his face. Barbara screamed at the boy to run. Although badly wounded, J.T. did. The man returned his attention to the mother. Barbara may have recognized him. He lived only two miles away. She may have known that he had been in trouble for burglary, that in 1986 he was convicted of raping his own mother, not once but at least four times. He was a strange man. Anthony Schroedel was someone who had never quite fitted in, who sported unnerving Satanic tattoos on his upper body.

He knew who Barbara was, too, and he knew that she was divorced. Whether he had come for burglary or sexual assault, he never managed to achieve either. Barbara fought too hard, receiving gashes and stab wounds as she fought for her life. But she was no match for his strong hunting knife and soon the life flowed out of her. And J.T. was gone. Schroedel didn't know where he went, but thought he had better get out of there. He hurried home, took a shower to wash off Barbara's blood and set fire to the clothes he had worn.

J.T., meanwhile, had staggered across a field to his grandparents' house, dripping blood all the way. Detectives found that trail later. But first they heard J.T. describe what had happened. They found Barbara dead in a blood-soaked house. Blood was everywhere, on the stairs, the front porch, in the living room and dining room.

J.T. was able to describe the intruder and said he thought he had seen him before. The description matched that of a homeless man and also Anthony Schroedel. Perhaps because of his record, they checked on Schroedel first. There they found the barrel of blood-drenched clothing that Schroedel was trying to burn.

When the case went to trial, Schroedel tried to convince the court that he had been stumbling around in the night, dazed and disoriented, perhaps even sleepwalking. Judge Frank LaBuda didn't buy it. Most sleepwalkers do not go about armed with knives and a flashlight, which Schroedel also had. Then there was the attempted coverup—the flight, the shower, the partially burned clothes. Nice try, Anthony.

Because of Barbara's murder, the attempted murder of J.T. and possibly Schroedel's past record, the district attorney planned to construct a death penalty case. Schroedel's lawyers pleaded for leniency on the grounds that he was mentally deficient. Under New York State law, a defendant who meets certain criteria regarding mental retardation is protected from the death penalty. Schroedel was examined by psychologists on both sides and failed to meet those criteria. Besides, the flashlight and the knife clearly indicated premeditation, and that was a problem.

The next ploy was an attempt to plead guilty. That, too, would have eliminated the death penalty. Schroedel took his appeal all the way to Albany. In the end, it was Barbara Vogt's family who spared his life. Some were against the death penalty on moral and religious grounds. Others thought he deserved it. But to go that way, the district attorney would have had to put young J.T., by then thirteen years old, on the witness stand. J.T. still had both physical and emotional wounds from that night. He had seen his mother savagely murdered. He still bore scars from the attack on himself. The district attorney agreed that it would only traumatize J.T. to face his near killer and have to describe once again the events of that night.

And so Anthony Schroedel, the man who may have been a dim bulb but was bright enough to premeditate a crime, the man who bore Satanic tattoos and raped his own mother several times, received a sentence that would keep him in prison for life plus 107 years.

She Trusted Him

New Paltz is actually east of the Catskills. It is, in fact, east of the Shawangunks, which are east of the Catskills, but the mountains and valleys are all close together in the same general area.

Robyn Conroy lived with her mother in a condo apartment on quaint Huguenot Street, so named because it was settled by

The old and the new: Huguenot Street in New Paltz. *Photo by Daniel Case.*

Huguenot immigrants in the seventeenth century. Their age-old stone houses still dot the street, along with such modern sights as automobiles and telephone poles.

Robyn was a timid girl with a cheerful smile and a petite, slender build. Her boyfriend, Michael Curtis, was six feet, five inches and weighed more than two hundred pounds. He was forty-three years old to Robyn's twenty-nine. Because of the disparity in their ages and size, and the paternalistic way in which he treated her, people sometimes mistook them for father and daughter.

Like so many men of his ilk, Curtis had a talent for zeroing in on vulnerable women whom he could manipulate. The shy, sweet and unassertive Robyn made a perfect target. She was so unassertive, in fact, so timid, that the owner of the convenience store where she worked sometimes worried about her. He said she could be frightened by a mere look. One time, when a customer questioned her about a price, she actually trembled.

Not only was Curtis a predator, he also had a record. It began when, at age seventeen, he set fire to a neighbor's house. For that, he was placed on probation. A few years later, in his native Dutchess County, he was convicted of rape. That led to his being classified as a Level 3 sex offender. Level 3s are considered the most dangerous, all too likely to repeat the offense.

During the 1980s, he committed several burglaries and another arson, as well as vehicular assault. In all those cases, he managed to plea bargain his way to a lighter penalty or no punishment at all. In 2002, he was charged with public lewdness for exposing himself in a Millbrook, Dutchess County park. For some reason, the charges in that case were dismissed and the records were sealed.

How much of this Robyn was aware of, we don't know. Certainly she was shocked and horrified when, in September of 2005, he was accused of raping another woman—Robyn's own mother.

That was when things became snarled in legal technicalities. Curtis was jailed while the district attorney's office tried to build a case. Their efforts were hampered by the fact that the victim, Robyn's mother, had trouble remembering the details, including the exact date on which the assault took place. Without her evidence they would have to drop the case and let Curtis walk, and that seemed a miscarriage of justice as well as a disservice to the public.

However, they were in a bind. If they held a preliminary hearing and lost it because of insufficient corroboration, Curtis would be out of jail free. But they couldn't hold him indefinitely without some sort of move on their part. And so they waived the preliminary hearing and were forced to release him while they collected more evidence to take before a grand jury.

Robyn's father, the victim's former husband, said later that they should have known there wouldn't be any more evidence. They should have realized his ex-wife was a person of "diminished capacity" and would not be able to offer much help. When he made that statement after the fact, he was thinking of Robyn. At the time, however, no one foresaw what would happen.

Nor did anyone intend for Curtis to be released unsupervised. He was, after all, a dangerous criminal with a record and a temper. The town justice sent a letter to the Ulster County jail ordering pretrial supervision as a condition of the release. But something went wrong with the protocol of that order. It failed to reach the right people in the correct and approved sequence

and the order was never carried out. So Michael Curtis walked free as a breeze. Meanwhile, the indignant and heartbroken Robyn felt compelled to end their relationship. How she went about it, no one knows. The discussion was a private matter between Curtis and herself. Only the aftermath came to public attention. Curtis was the type of person who refuses to be dumped, even if the reason is understandable. Whether they fought, or exactly what they fought about, only Curtis would know and he never discussed it. What did become evident was that, with his big, strong hands around Robyn's slender neck, he ended her life. But not before he raped her, it was later found.

To conceal his crime, he stuffed her body into a Dell computer box and set fire to the apartment. He did rescue something that belonged to her, namely $2,000 in cash, which he took with him.

The fire damaged several apartments in that building but it failed to destroy the evidence of murder. Robyn's body was found and it didn't take anyone long to figure out who killed her. They arrested Michael Curtis that same day, November 22, 2005.

Once in the hands of the authorities, he confessed to having committed first- and second-degree murder. That admission may have gotten him a lighter sentence. It did not sit well with Robyn's family that the man who strangled and tried to burn her, who had a string of heinous offenses on his résumé, was sent to prison for only twenty years to life. It didn't seem like nearly enough, when he had taken *all* of Robyn's life.

The Iron Fist

Tracey Passaro, at thirty-seven, had an asthma problem so serious it kept her from working. Her forty-year-old husband, Anthony, was also on disability. He had multiple sclerosis, so the neighbors said. He seemed to get around all right. MS has its ups and downs. It can go into remission and then hit again, hard.

The couple lived in a modest bungalow on a modest street in Saugerties. They had two children, a nine-year-old boy and a five-year-old girl about to turn six. Tracey had already planned the birthday party, invited friends and family and prepared to bake a cake. She had visited an animal shelter and brought home a kitten for the little girl.

His illness did not keep Anthony from ruling the roost. He was, everyone reported, a controlling, domineering husband. As one neighbor put it, "When he said jump, she jumped." He was also known for his verbal abuse of her, even in public. That can damage a woman's soul even without physical abuse to hurt her body.

But Tracey stayed on, trying to keep the family together and make their lives as normal as possible. Her children were most important to her. For them, she would have done anything. She was a gentle, kindly person, neighbors said, who wouldn't hurt an insect.

Even a gentle, kindly person can have enough. That will often happen when she feels her children might be in danger. Whatever the precipitating cause, Tracey had decided to leave her husband and make a life for herself and her children. For a homemaker and mother, that's a big step. She was still trying to figure out how she would do it, especially the financial part. She would need an apartment that she could afford and all the other necessities of life. Still, it would be worth it if only to have some peace and self-respect. If only so she wouldn't have to tiptoe all the time to avoid setting off a live grenade.

Those who work in the field of domestic abuse all agree that this is the most dangerous time in an abusive relationship. Control is a big thing for a controlling husband and he loses that if his wife gets away. It pulls the props out from under him. He is left with nothing but a blow to the ego, and that is intolerable.

Some of the couple's friends believe the fight was over the kitten. That may have started it, or it may not. The fact that Tracey planned to leave him was certain to cause a blowup. Whatever

Anthony Passaro. *Photo by Beth Blis for the* Saugerties Times.

happened, it was early in the morning on a late September day, just the day before their little daughter's birthday. Tracey was up but not dressed, still wearing her pale pink bathrobe. The time was not quite 7:00 a.m. when the woman next door thought she heard a gunshot.

Then came the call to 911. It was probably made by the couple's nine-year-old son. Neighbor Harry Borrero looked out and saw emergency vehicles arrive at the house. He assumed Tracey had had another asthma attack. Soon the police were there. Borrero saw Anthony handcuffed. Shortly thereafter, Borrero himself became involved.

The Passaros had a golden retriever who protected the home. The dog thought it was his job to keep intruders away, and the police were obviously intruding. Because Borrero and the dog knew each other, the police sent him inside to subdue it so they could enter. That was when he saw Tracey lying on the floor in her pink bathrobe, her head resting in blood.

She had been shot with a .223-caliber rifle. The house, in fact, contained quite a few guns, including handguns, for which

Anthony had no permit. It was a dangerous house, especially with children there, and Anthony was a dangerous person. Tracey's relatives reported that he was subject to mood swings and fits of depression. On more than one occasion he had attempted suicide. In the end it was his wife he killed, and not himself. Her relatives thought it should have been otherwise.

Anthony made no effort to hide what he had done. He told the police quite freely that he had shot his wife. Both children were in the house when it happened. The little girl told a neighbor, "My daddy shot Mom in the head."

Anthony Passaro was charged with second-degree murder, felony possession of a weapon and two counts, both misdemeanors, of endangering the welfare of a child.

The birthday party was canceled.

A Family Affair

Unionville is in southwestern Orange County, not quite the Catskills, but near them. In late 2007, it was the scene of a house fire that could have cost seventy-one-year-old John Doyle his life. Perhaps that was the whole idea.

Doyle was at home when the first fire started. It was in his basement, chewing up a pile of newspapers and magazines. He managed to stamp it out himself and thought that was the end of it. It wasn't the end. There were other fires. He came home from doing some errands and found a mattress blazing. That conflagration was larger and more damaging. The basement walls were burned, as well as some floor joists, electrical wires and plumbing connections. It looked suspicious and it took the fire department to put it out.

The state police were called in. To them, too, it seemed suspicious. Evidence pointed to Doyle's daughter-in-law, Tracey. Arrested with her were her two children: Donald, sixteen, and Shannon Kays, nineteen, as well as a friend, Michael Springer,

twenty-two. They were charged with attempted murder in the first degree.

Because the murder was not actually accomplished, they were allowed to plead guilty to arson, which let them off more easily. For Tracey, the arson was second-degree, and for each of her children, third-degree. Springer pleaded guilty to reckless endangerment. All those crimes are felonies.

Even with the several fires they started, this crew failed to achieve anything except some prison time. The district attorney referred to them as "the gang that couldn't shoot straight."

Tracey, evidently the ringleader, was sentenced to ten years in state prison. Sharon Kays received two to six years, and Donald, one to three. He was classed as a youthful offender, which means his record will be sealed. Michael Springer faced one to three years.

For four decades, the house had been John Doyle's home. Why Tracey took it into her head to make it his funeral pyre, and put her children's future at risk, is not known at this time.

"Yankee Jim"

You either hated or adored him, depending on whether you agreed with his views. He called himself an activist but did not care for the label "white supremacist." He considered it extreme. He thought "white separatist" said it better. He kept a blog in which he aired such opinions as: "Racial segregation is the only solution. How many more white people have to suffer?" He had a passionate following of those who shared his opinions. To most people, he seemed sick and filled with hate.

James Leshkevich wore his hate unabashedly, putting forth his views at every opportunity. He expressed them freely to the children in his neighborhood. He passed out anti-Semitic literature at a pro-Israel rally. He organized a rally of his own in Kingston in November 2005. There had been a racial incident

at the high school, in which a white student was assaulted. When the charges were dismissed, Leshkevich was outraged. He wrote, "You white people in Kingston and the surrounding area who are worshipping those colored boys are sick and need help." He brought in like-minded people to support his rally. There were counter demonstrations, but no violence. He and his supporters were definitely in the minority, but they were allowed their free speech.

Deborah Leshkevich, his wife, worked as a teaching assistant at the Woodstock Elementary School. An attractive fifty-five-year-old, she was the mother of three grown children, two of them from her marriage to Jim. Coworkers described her as a kind and caring person who went the extra mile to help the children in her classes. Many found it hard to believe that she was married to the angry man who took his neo-Nazi stand so openly.

And angry he was. He made no bones about it. Over the seventeen years he lived on Morgan Hill Road in West Hurley, neighbors could hear him shouting caustic comments at his children. A friend of Deborah's considered her an abused wife, "absolutely." Some speculated that, with her children now out of the home, Deborah, too, might consider leaving.

There is no public record of Deborah's thinking or plans. James, however, went public with his own take on the subject. Early in February 2008, he posted a long and rambling blog in which he claimed his wife was sleeping with another man. According to him, she came home at four o'clock in the morning; later he overheard a "steamy" cellphone conversation with the man in question.

He must have heard a lot of it. He quoted her nearly verbatim. To her friends, it all seemed totally out of character. It sounded, in fact, exactly like the rantings of a hate-filled man. James quoted her as taunting him when he confronted her about the relationship. He went so far as to name the other man, who, not surprisingly, denied any involvement.

How many of those allegations were true? To those who knew Deborah, they couldn't have been. Was it a setup? Was he cleverly

preparing justification for what he planned to do? No one knows. He said it was the last blog he would be writing "for a while."

On Tuesday, February 19, Deborah failed to show up at the school. Concerned, those who worked with her called the state police. On entering the Leshkevich home, police discovered Deborah lying dead in the bedroom. A further search led to the garage, where they found James. He had hanged himself. He had also left a suicide note, the contents of which were not disclosed.

An autopsy revealed that Deborah first suffered "blunt force trauma" to the head and then was strangled. A murder-suicide, police called it. James's admirers were distraught, pouring out their grief and admiration in blogs and forums, heaping praise on the hero they regarded as a martyr and condemning Deborah for destroying him. Feelings ran so high that the man he named as Deborah's lover received threats of retaliation. The police took those seriously.

As for Deborah, she had no chance to give her side of the story. How aware she was of the venom spewed in Jim's blog, we don't know. But she had her defenders. Many blogs were posted that expressed disgust at Jim's views and the way he had treated his wife. Some took the opportunity to condemn domestic violence in general, calling it a war against women.

By his own admission, Yankee Jim was at war. With much of the world, it seemed. Where such hate came from is another unknown.

A resolution of the case stands at murder-suicide. Jim's admirers called it a tragedy. And it was—for both the unhappy Jim *and* his wife.

Done in by a Parachute Cord

She had a drug and drinking problem. She had been fired from her last job as a waitress at the Quickway Diner in Bloomingburg. But Tammy was a good person, said her sister, Toni Valentine. She

loved her family, her two children. Nevertheless, Tammy felt she was not cut out to be a mother. She had left her young daughter in Toni's care, in Florida. In Tammy's opinion, the girl was better off there, with a stable family. From Florida, Tammy moved to North Carolina and got a job as a waitress. There she met Hal Karen, who was in the army. In the special forces, to be exact. He was a parachutist.

They married. They had a little boy. They lived out west in Washington for a while. Hal retired from the service and they moved to Bloomingburg, New York, where his parents lived.

Even before that, Tammy's behavior was erratic at times. In Washington, she was arrested for assault—on Hal. She struck him with an iron. She disappeared for three days with no explanation. Drugs can do that to a person. It can make them lose their way. Or go out looking for another fix.

In Bloomingburg, the unpredictability continued. She did well and was liked at the Quickway Diner. But several times she failed to show up for work. They had to let her go.

She called her sister regularly and talked to her daughter, who was then thirteen years old. She told Toni she didn't think she was a good mother. Family life was not her thing. She wanted to visit Mexico.

In June 1999, her husband said, she packed a bag. She told him she was going to Mexico with someone she knew from the diner. She told her little son that she loved him and that Daddy would take care of him. At three o'clock in the afternoon, Hal reported, someone came in a small red car and picked her up. He didn't recognize the car. All he knew was, Tammy had gone.

A month went by. Two months. Toni Valentine waited for a call. Her sister *always* called, but none came. Not for two whole months. That went beyond unusual. It was worrisome. Toni notified the state police that her sister was missing. Something just wasn't right.

Police tracked down the friend who supposedly accompanied Tammy to Mexico. The friend said Tammy hadn't been on that

trip. They checked with U.S. Customs. There was no record of Tammy crossing the Mexican border. They posted information about Tammy on nationwide databases. They interviewed more than a hundred people and got no leads. Each time an unidentified female body showed up, they checked that, too. No Tammy.

Over and over, Hal repeated what he'd told them of Tammy's departure. The red car. The suitcase. It was a small one, he said, patterned with white flowers. She had packed her address book and some pictures of her children, as well as clothes. He had also discovered, after she left, that she'd taken $500 from his wallet, for the trip. Or for drugs.

More time went by. A year. Tammy never called, not even once. Toni kept after the police, not letting them brush aside the problem. She just knew something was wrong. It didn't make sense that nobody had heard from Tammy. She certainly would have called her daughter on the girl's birthday. Or Christmas.

Tammy and Hal lived in High View on the Shawangunk Ridge, just above Bloomingburg on one side and Wurtsboro on the other. Where the road descends into Wurtsboro, it makes a sharp turn. On the western side of that turn, the ground falls steeply away and is densely wooded. It was March 2002, and the leaves were not yet out, when a teenage couple rode through the woods on an ATV. They were looking, said the vehicle's driver, for tree stands to use in the deer hunting season next winter. What they found instead was a trash can, securely tied with garbage bags and a green nylon cord.

Overcome by curiosity, the young man looked more closely. He saw a bra, he said. He saw bones. A sweater. A wristwatch. At that point, in his own words, he "freaked out" and didn't look any further. He ran home and called the police.

Whoever had been packed into that trash can was now only a skeleton. A few bits of mummified tissue clung to the bones. There wasn't much to work with. The identification process was complicated and took a long time. Somehow, they managed to extract some usable DNA. They then obtained DNA from

Tammy's relatives in Florida. It matched. Tammy Karen hadn't gone to Mexico after all. She had been near home all along, all those three years she was missing.

That alone was enough to poke holes in Hal's story of her gala departure. But it was the nylon cord that clinched it. Investigators took one look at the cord, and they knew: it was parachute cord. Even more specifically, it was a special kind used by parachutists in the U.S. Army Special Forces. Hal Karen had been a parachutist with the special forces.

When confronted with that evidence, Hal changed his story. He had come home, he said, and found Tammy dead on the bathroom floor between the sink and the toilet. From an overdose, he surmised. There were crack vials nearby. He panicked, fearing that if the authorities knew she had died from drugs, they would take away his little boy. So he bundled her into the trash can, tied it securely and placed it in his truck. At three o'clock in the morning, with his little boy beside him in the cab, he drove to that sharp turn in the road and rolled his wife down the embankment into the woods. There Tammy lay for almost three full years.

That story didn't wash with the district attorney. If a husband found his wife dead, from whatever the cause, a more plausible reaction would have been to call 911. Let someone with more expertise pronounce her dead. Let her have a proper burial. And why would anyone take away his son? After all, Hal was not the addict in the family. His disposal method clearly smacked of homicide. He was arraigned on a charge of murder. Hal pleaded innocent to the charges. It meant he had to go on trial.

After Tammy's disappearance—or death—Hal had moved to Swan Lake, farther west in Sullivan County. Police searched both that home and the old one in High View. They found more of the same nylon cord, as well as Tammy's address book that Hal said she had taken with her. They also found more crack, which did not surprise them. Tammy was known to be addicted.

Hal's attorney worked hard, trying to suppress his client's early statements to the police. He also tried to keep the rope from being brought in as evidence. The judge refused to go along with either of those ideas, and ruled that both should be admitted. Even the "end-of-the-bowline knot" with which the rope had been tied was one commonly used by special forces paratroopers. Hal must have hoped the trash can would never be found. Or that no one would recognize parachute cord when they saw it.

An autopsy proved difficult, as there was very little left of Tammy. Dr. Michael Baden, a world-renowned forensic pathologist, was tops in both skills and experience. From what samples he had to work with, he found that there was not enough cocaine in the body to have caused death. Instead, he testified, she died from traumatic asphyxiation. Her oxygen supply had been cut off. Probably she was strangled.

The defense attorney, seeing that this could be open to question, hired a pathologist who, not surprisingly, considering he was working for the defense, contradicted Dr. Baden's testimony. Dr. James Gill reviewed the earlier report, the toxicology report, as well as photographs, and reached the conclusion that Tammy's death could indeed have resulted from a drug overdose. Or rather, that it couldn't be ruled out. He was disputed on the grounds that he hadn't examined the body itself, as Dr. Baden had done.

An investigating officer poked more holes in the version Hal had offered. It was impossible, he said, given the layout of the bathroom, for a body to be in the position Hal described, between the toilet and the sink.

Hal's attorney kept trying, leaning on Tammy's history of drug and alcohol abuse and her erratic behavior, trying to convince the jury that this was proof she had died of an overdose. Furthermore, he pointed out, it was on record that Hal had obtained an order of protection after Tammy disappeared. A few months later, Hal filed for divorce. That could well be consistent with a coverup, not necessarily with innocence. The jury was not persuaded.

The trial lasted for two weeks. Hal was convicted of second-degree murder and of perjury for his three-year lie to the police about her disappearance.

Even then, his attorney did not give up. Instead, he asked that the conviction be set aside and a mistrial declared, on the grounds of jury misconduct. One underage juror had been seen drinking beer while another juror announced at the beginning of the trial that she thought Hal Karen was guilty. Each member of the jury was questioned. An appeals court concluded that there was insufficient cause to call a mistrial.

Hal Karen was sentenced to a term of twenty-six years to life. His little son, who by then was six years old, was being raised by Hal's parents.

In the fall of 2003, New Dominion Pictures shot an episode about the case for the program *New Detectives* on the Discovery Channel. They used some of the real people who had been involved, all on the law enforcement side, when they reenacted a scene at that sharp turn in the road going down into Wurtsboro. It was the scene in which the trash can, Tammy's tomb, was brought up from its three-year resting place seventy-five feet down the wooded embankment.

REFERENCES

Associated Press. "Veronica Lake's ashes found in Catskills."
October 12, 2004. www.msnbc.msn.com. Accessed November 1,
2007.

Brooks, Paul. "Human bone unearthed beneath garage." *Times
Herald-Record*, July 22, 2003.

———. "Saugerties Man Shot, Killed Wife during Fight, Cops
Say." *Times Herald-Record*, September 27, 2007.

Brooks, Paul, and Oliver Mackson. "Curtis Fell Through the
Cracks." *Times Herald-Record*, December 18, 2005.

Bruno, Anthony. *The Bonanno Family*, n.d. www.trutv.com/library/
crime/gangsters_outlaws/family_epics/bonanno. Accessed May
31, 2008.

Capeci, Jerry. "Wedding Bell Blues." *This Week in Gang Land*, August
3, 1998. www.ganglandnews.com. Accessed June 4, 2008.

Conway, John. "The Beginning of the End for Murder, Inc."
Retrospect, March 14, 2008. www.sullivanretrospect.com. Accessed
May 6, 2008.

———. "The Canary Who Sang, but Couldn't Fly." *Retrospect*,
March 21, 2008. www.sullivanretrospect.com. Accessed May 6,
2008.

———. "The Corpse in the Tailor-Made Suit." *Retrospect*, May, 30,
2008. www.sullivanretrospect.com. Accessed May 31, 2008.

———. *Dutch Schultz and His Lost Catskills' Treasure*. Fleischmanns,
NY: Purple Mountain Press, 2000.

———. "The Saga of Jacob Gerhardt…Continued." *Retrospect*,
December 14, 2007. www.sullivanretrospect.com. Accessed May
6, 2008.

REFERENCES

―――. "The Unrequited Love of Jacob Gerhardt." *Retrospect*, December 7, 2007. www.sullivanretrospect.com. Accessed May 6, 2008.

―――. "The Worst Woman on Earth." *Retrospect*, November 23, 2007. www.sullivanretrospect.com. Accessed April 22, 2008.

Daily News. "Kiki's Love Cost Life of Diamond." December 19, 1931.

"Dutch Schultz," *Wikipedia*, n.d. en.wikipedia.org/wiki/Dutch Schultz. Accessed April 25, 2008.

Frederick (Maryland) *News*. "A Murderous Maniac." September 11, 1893. http://www.casebook.org/ripper_media/book_reviews/non-fiction/cjmorley/76.html. Accessed April 19, 2008.

Fried, Joseph P. "Following Up." *New York Times*, September 1, 2002.

Gangster City Profiles. n.d. www.patrickdowney.com. Accessed May 31, 2008.

Gerace, Joseph M. "Mother, Son and Daughter Charged with Attempted Murder of In-Law, Arson." *Daily Freeman*, October 27, 2007.

"Joseph Bonanno," *Wikipedia*, n.d. en.wikipedia.org./wiki/Joseph_Bonanno. Accessed May 20, 2008.

"Kempthorne Brought Major Shift on Off-Reservation Gaming." www.indianz.com. January 30, 2008. Accessed June 4, 2008.

Kirby, Paul. "Racism Was a Way of Life for 'Yankee James.'" *Daily Freeman*, February 20, 2008.

―――. "Slain Wife Was Making Plans to Move Out." *Daily Freeman*, September 30, 2007.

―――. "Woman Shot to Death in West Saugerties; Husband Charged with Murder." *Daily Freeman*, September 27, 2007.

Krajicek, David J. "Betrayal and Murder." *Daily News*, October 21, 2007.

Kroeger, Brooke. n.d. *Nelly Bly*. http://brookekroeger.com/nellie/nellie.html. Accessed May 13, 2008.

"LeGrand, Devernon." Serial Killer True Crime Library. www.crimezzz.net/serialkillers/L/LEGRAND. Accessed November 30, 2007.

"Louis 'Lepke' Buchalter." *Murder Inc. FBI Files*. n.d. www.paperlessarchives.com/buchalter.html. Accessed April 19, 2008.

Mackson, Oliver. "Conroy Slaying Suspect Weighs a Plea of Insanity." *Times Herald-Record*, May 24, 2006.

————. "Daughter-in-Law, 2 Kids Get Prison for Arson." *Times Herald-Record*, March 14, 2006.

————. "Man Indicted in Woman's Death." *Times Herald-Record*, January 8, 2006.

————. "Rape Charge Filed against Murder Suspect." *Times Herald-Record*, May 6, 2006.

————. "Victim's Dad Faults DA." *Times Herald-Record*, February 14, 2006.

Marion (Ohio) Daily Star. "Guilty of Murder." September 14, 1893. http://www.casebook.org/press_reports/marion_daily_star/930914.html. Accessed April 19, 2008.

Marshall, George L., Jr. "Chief Joseph Brant: Mohawk, Loyalist, and Freemason." www.earlyamerica.com. 1998.

May, Allan. "Waxey Gordon's Half Century of Crime." *Crime Magazine*, n.d. www.crimemagazine.com/waxey.htm. Accessed May 14, 2008.

McQuiston, John T. "Son Is Arrested in the Killings of His Parents, Both Lawyers." *New York Times*, November 27, 1999.

Middletown (New York) Daily Times. "More about Mrs. Halliday." December 4, 1893. http://www.casebook.org/press_reports/middletown_daily_times/931204.html. Accessed April 19, 2008.

Minisink Valley Historical Society. "The Battle at Minisink Ford." n.d. www.minisink.org/minisinkbattle.html. Accessed April 14, 2008.

Miraldi, Robert M. "Police Confirm Leshkevich Deaths Were Murder and Suicide." *Daily Freeman*, February 20, 2008.

Murder Incorporated. "Irving 'Waxey' Gordon." May 7, 2006. http://toughjews.blogspot.com. Accessed May 14, 2008.

New York Times. "Held for Markert's Murder." January 28, 1892.

————. "Lizzie Halliday Soon to Be Tried." June 10, 1894.

————. "Long Island Man Admits Killing Parents and Burning Their Bodies and House." August 31, 2000.

————. "Major Figure Facing Trial in Mob War Is Arrested." July 31, 1998.

————. "Murderer Adam Heidt Dead." July 24, 1897.

————. "Teazed into Murder." April 2, 1897.

————. "To Be Tried for Murder." June 12, 1881.

————. "A Victim of Superstition." January 26, 1892.

Penick, Tom. "The Story of Joseph Brant." n.d. www.indians.org/welker/brant.htm. Accessed March 23, 2008.

"Peter Barmann Brewery History." www.angelfire.com/ny5/brewerianakingston/barmann.html. Accessed May 31, 2008.

Quinn, Erin. "Curtis Case Goes Before Grand Jury on December 29." *New Paltz Times*, November 8, 2007.

Rockwell, Reverend Charles. "Legends, Biographical Sketches." *The Catskill Mountains and the Region Around.* www.catskillarchive.com/rockwell. 1867.

Sann, Paul. *Kill the Dutchman: The Story of Dutch Schultz.* www.killthedutchman.net. 1971. Accessed April 15, 2008.

Silverman, Francine. "The Legend of the Hex Murder." *The Catskills Alive!* http://books.google.com. Accessed April 12, 2008.

Smith, Jesse J. "After the Storm." *Saugerties Times*, October 4, 2007.

————. "Hurley Mountain Breakdown—Notorious White Supremacist Kills Wife, Hangs Self." www.theweeklybeat.net. February 22, 2008. Accessed May 23, 2008.

————. "Saugerties Rocked by Domestic Killing of Young Mother." *Saugerties Times*, September 27, 2007.

Smith, Philip H. *Legends of the Shawangunk.* Syracuse, NY: Syracuse University Press, 1965. First paperback edition, 1977.

Stone, William L. *Three Rivers: Hudson~Mohawk~Schoharie. Border Wars of the American Revolution.* New York: Harper & Brothers, 1843. http://books.google.com/books?hl=en&id=WusNAAAAIAAJ&dq=%22Joseph+Brant%22&printsec=frontcover&source=web&ots=f0CC9z79Uw&sig=8XvkIpDeEHuePLk9FMlk0H2Pvx0&sa=X&oi=book_result&resnum=4&ct=result. Accessed April 17, 2008.

Time. "Murder, Inc.," April 1, 1940. www.time.com. Accessed June 2, 2008.

Times Herald-Record. "Indian Casinos Here All But Dead." February 10, 2008.

————. "Interior Secretary Rejects Catskill Casino Plans." February 10, 2006.

———. "Mom, Kids Plead Guilty to Arson for Trying to Torch Father-in-Law's Home." January 16, 2008.

———. "Mystery Skeleton Reveals Few Clues." October 27, 2007.

———. "Unionville Woman and Children Indicted on Attempted Murder Charges." November 5, 2007.

Tuohy, John William. "The Raid at Apalachin," November 2001. www.americanmafia.com. Accessed April 27, 2008.

Turkus, Burton B., and Sid Feder. 1951. *Murder, Inc.: The Story of the Syndicate.* Reprint, Cambridge Center, MA: Da Capo Press, 1992.

Waddell, Ted. "Hal Karen Found Guilty." *Sullivan County Democrat,* April 11, 2003.

———. "Prison Coming for Hal Karen." *Sullivan County Democrat,* June 20, 2003.

———. "Schroedel Case's Conclusion Satisfies DA, Sheriff, Judge." *Sullivan County Democrat,* April 10, 2001.

———. "Schroedel Sentenced to Life in Prison." *Sullivan County Democrat,* May 22, 2001.

Wood, Barbara. "Fast Guilty Plea in Killing Rejected." *Times Herald-Record,* January 14, 1998.

Yakin, Heather. "Appeals Court Upholds Murder Conviction." *Times Herald-Record,* April 23, 2005.

———. "Cop Recalls Boy's Account of Murder." *Times Herald-Record,* March 20, 2000.

———. "Cord Vital to Sullivan Murder Indictment." *Times Herald-Record,* September 26, 2002.

———. "Death-Penalty Case Forming." *Times Herald-Record,* August 17, 2000.

———. "Death-Penalty Cases Long and Complicated." *Times Herald-Record,* July 14, 2000.

———. "DNA Reports May Be Key to Murder Case." *Times Herald-Record,* December 6, 2000.

———. "Ex-Paratrooper on Trial in Wife's Slaying." *Times Herald-Record,* March 25, 2003.

———. "For Killing Wife, Karen Gets 26 Years to Life." *Times Herald-Record,* June 20, 2003.

———. "Husband Charged 3 Years after Wife's Disappearance." *Times Herald-Record,* August 8, 2002.

———. "Husband Pleads Innocent to Charge of Killing Wife." *Times Herald-Record*, October 1, 2002.

———. "Husband's Story of Overdose Possible, Medical Examiner Says." *Times Herald-Record*, April 3, 2003.

———. "Husband's Trial Hits Second Day." *Times Herald-Record*, March 26, 2003.

———. "I Found Wife Dead, Suspect Says." *Times Herald-Record*, February 26, 2003.

———. "Lab Work Key to Husband's Murder Charge." *Times Herald-Record*, August 9, 2002.

———. "Over a Year Later, Still No Signs of Missing Woman." *Times Herald-Record*, July 17, 2000.

———. "Spouse's Murder Conviction Stands, LaBuda Rules." *Times Herald-Record*, June 11, 2003.

———. "Swan Lake Husband Guilty of Murder." *Times Herald-Record*, April 9, 2003.